T0303773

PARANORMAL
CORNWALL

DAVID SCANLAN

AMBERLEY

In loving memory of my father Dennis Scanlan (1940–2021),
my greatest friend, supporter and mentor for 45 years.

And

In memory of Richard Atkin (1973–2012),

my friend and fellow ghost hunter for many years.

'You are a child of the universe,
no less than the trees and the stars;
you have a right to be here.
And whether or not it is clear to you,
no doubt the universe is unfolding as it should'

Desiderata – Max Ehrmann

First published 2021

Amberley Publishing
The Hill, Stroud
Gloucestershire, GL5 4EP

www.amberley-books.com

British Library Cataloguing in Publication Data.
A catalogue record for this book is available from the British Library.

ISBN 978 1 4456 9469 6 (print)
ISBN 978 1 4456 9470 2 (ebook)

Typesetting by SJmagic DESIGN SERVICES, India.
Printed in Great Britain.

Contents

Acknowledgements

The writing of any paranormal book is only ever possible with the assistance of the people that live, work or visit the haunted locations featured. Throughout the writing of *Paranormal Cornwall* I have been very privileged to speak to many people in the county who have told me their tales of the paranormal and my thanks go to Richard Atkin of the Hampshire Ghost Club who accompanied me to Bodmin Jail, Jamaica Inn and numerous other haunted places throughout the county; Christian Adams, Mark Rablin, Martyn Boyes, Paul Dutton and Ron Teskowski, Haunted Happenings; *The Bridgwater Mercury*, Clare Lewis; Summer Scanlan for her photographs; Hannah Fox; Garry and Zoe Seymour; Graham King and James Stephens; Paul Ellis for his proofreading of this manuscript and noted suggestions; and Lesley Johnson and Richard Abbott for their historical research skills. For any names not mentioned, please forgive me. This has been purely due to space constraints. My sincere thanks also go to my friend and parapsychologist Dr Callum Cooper for his excellent foreword and of course my final thanks must go to my family and friends who were dragged endlessly around numerous haunted places during the writing of this book. I thank you all.

Images and Photos Used in *Paranormal Cornwall*

Where possible I have attempted to use my own images in the context of this work. Some images have been supplied by members of the public, paranormal investigators and researchers and others used have come via public domain sources such as Wikimedia Commons. Where possible I have credited the authors of the images with their stated names and source. These authors do not endorse me or my use of their images and any copyright infringement is unintentional. Copies of the Creative Commons Share Alike licenses can viewed by visiting the following websites.

https://creativecommons.org/licenses/by-sa/1.0/legalcode
https://creativecommons.org/licenses/by-sa/2.0/legalcode
www.creativecommons.org/licenses/by-sa/3.0/legalcode
https://creativecommons.org/licenses/by-sa/4.0/legalcode

Foreword

Great Britain, without a doubt, boasts *the* most haunted locations in the world, and within the country you have every county claiming that they are riddled with tales of ghosts, ghouls and spectres from myth and legend, to present-day occurrence. Any system to rate the 'most haunted' area would likely be flawed, and I personally believe that such a claim to paranormal fame can only come down to personal experience, preference and reputation. With that being said, I believe Cornwall has a lot to offer people with regard to its history of hauntings and strange goings-on.

Having had many enjoyable conversations with David Scanlan on theories of the paranormal, and after having read his previous books on haunted areas of the country, I am delighted that he has taken the time to research Cornwall and present a fair overview of its ghostly history. In doing so he presents each location and its history with an honest personal insight from his travels as a tourist and as a paranormal investigator.

My early beginnings in ghost-hunting involved spending time in haunted pubs up and down the country. This began my initial interest in parapsychology and pursuing a career into the scientific exploration of psychic phenomena. However, I have never ventured as far as Cornwall at present to investigate their claims of anomalous experiences in purportedly haunted locations.

Scanlan's book acts as an excellent guide to those who either know Cornwall and wish to embrace its spooky history further, or acts as a preparation guide to those who wish to make the trip and explore its paranormal places. Two particular pubs in Cornwall which have always fascinated me from reading Guy Lyon Playfair's *The Haunted Pub Guide* are the Jamaica Inn and the Dolphin Inn.

The Jamaica Inn has been labelled as the most *famous* inn in the world, and is argued to have two different ghosts – one being a phantom sailor seen sitting on the wall outside the building, and is never seen to move, and the other has been seen in the last bedroom on the right at the end of the corridor, this being the figure of a man wearing a long old-fashioned coat and a tricorn hat. This particular ghost is seen to move and pass through objects, and in one such case, vanished into a wardrobe.

With the Dolphin Inn along the southern coast of England, this quaint pub has produced reports from multiple witnesses of footsteps marching up and down the corridor and going down the stairs with no explanation for their cause. While Room 5 had frequent reports of pipe tobacco scattered over the floor, and the bed often showed signs of having been slept in. These incidents were related to be the spectral work of the late pioneer tobacco importer Sir Walter Raleigh who had occupied the Dolphin in 1586.

I shall refrain from the retelling of any other accounts, and shuffling further through my memories of reading up on the hauntings of Cornwall. Instead, a wide selection of allegedly haunted locations have been compiled and researched, and are now presented before you – by one dedicated individual. In many books on haunted locations, they have been written by historians or local journalists who don't always have a vested interest in the paranormal. With this book on haunted Cornwall, I hope the reader will appreciate something more from the pages. Not only are the accounts produced from someone who took the time to visit and research the locations, but they are also presented by someone who is an experienced, open-minded and competent ghost-hunter.

Dr Callum E. Cooper
University of Northampton, Exceptional Experiences
and Consciousness Studies (EECS) research group

Introduction

Cornwall is an amazing county; a real gem in the crown of the United Kingdom. Its history is as fascinating as its myths, legends and ghost stories. Throughout the past few years I have written a number of books on the hauntings of various counties including Hampshire, Wiltshire, Sussex and Essex but Cornwall has to probably be the most open county I have ever written about. Its people and its places readily and happily discuss their ghosts and how they got there. Cornwall has it all. From ghostly ships seen traversing the coastline, phantom smugglers, pirates, suicides, murder victims and of course the legends of pixies, giants, fairies, Merlin, Camelot and the famed and mystical King Arthur. One thing I need to set out in this introduction is what this book contains. Remember the title – *Paranormal Cornwall* – true ghost stories. And that's what it is. I have only tried to relate aspects of ghosts, phantoms, spooks and spectres in the pages that follow. I have had to, sadly, omit the fantastic legends of King Arthur and the many, many intriguing myths and legends that go into making the county of Cornwall. Please do not think this is out of disinterest as I do this simply to keep to the constraints of this work.

I hope you enjoy reading *Paranormal Cornwall* as much as I have enjoyed writing it, and as I sit here overlooking St Ives Bay from Hayle Beach I hope that you will make the effort to investigate and visit many of the haunted places mentioned within these pages. I assure you they are all well worth the time and effort.

What Are Ghosts?

Since the beginning of recorded history every civilisation on this pale blue dot that we call Earth have experienced ghosts. From tribes deep in jungles to the most advanced peoples of this world living their high-tech lives in sprawling cities, people have reported these unusual and unexplainable encounters. But what are they?

There are many theories that attempt to explain ghosts. The most mundane of these is that the experiences of those who witness these apparitions are having nothing more than some kind of unusual hallucination. Maybe this hallucination has been brought on by grief, mental health issues, drugs, alcohol, naturally occurring imbalances in the natural environment (such as strong electromagnetic influence), prior knowledge of a venue being haunted or the expectation to see a ghost, such as on a paranormal investigation. Whilst all these potential explanations are valid, to a certain extent, they cannot explain all occurrences when people report seeing these spooks and spectres and don't fall into one of the above categories.

One very popular theory that could explain some ghosts has become known as the Stone Tape theory. Many researchers and paranormal aficionados subscribe to the belief that it is possible for a person's emotions to, somehow, become recorded into the fabric of a building or location when a person has been subjected to a particularly traumatic experience, such as a murder or another strong emotional event. When conditions are right these 'recordings' of past events can play back and be watched by the witness, similar to watching a film from bygone days. This theory fits well with ghosts that do the same things, come back at the same time of year or day, walk through walls or appear to be walking on a lower surface level such as in the experience of Henry Martindale, a plumber, who whilst working in the cellar of the Treasurers House in York claimed to have seen a group of Roman soldiers emerge from a solid brick wall. Mr Martindale could only see the spectres from the knee up until the ghosts walked onto the old Roman road, which ran through the cellar. When the ghosts reached this road he could see them from the knee down. Although this theory is popular it should be mentioned that it is only speculation.

Another theory is that ghosts are indeed the spirits of the deceased and somehow they can either choose to remain in a place, due to happy or sad memories, the feeling of needing to right some wrong done to them in life or choose to return to certain places in visitation. Mediums, people who profess to be able to talk to the spirits of the departed, claim that death is just an illusion and that life is eternal. They believe that when a person passes away their spirit, their consciousness, escapes death and continues to survive. There are many testimonies from people who have had sittings with mediums and claim to have been given irrefutable proof that their loved ones live on. On the other side of the coin many sceptics denounce mediums and claim that their evidence of life after death is nothing more than fraud and cold reading.

The reader will have to make up their own mind with regards to the above two mentioned theories but one simple thing to bear in mind is that a ghost will not respond to you, enter conversation or acknowledge your presence whereas a spirit, who is believed to be a sentient and intelligent being, will acknowledge, pass on information and recognise your presence. Whatever it is you choose to be, believer or sceptic, it shouldn't stop you from investigating the paranormal. It is a fascinating field of study to be involved in.

Other Types of Ghosts

In addition to the classic ghost and spirit descriptions discussed above there are some other examples of unexplainable phenomena I feel it is worth giving a brief description about.

Cyclical Ghosts

These are a classic 'Stone Tape theory' type of ghost. They can be seen, it is claimed, to appear at regular intervals such as the anniversary of a battle. One of the most famous cases of this type of ghost occurs at Marston Moor in Yorkshire. On 2 July 1644 a large battle between the Parliamentarian forces, led by Lord Fairfax and the

Earl of Manchester, against the Royalist forces of Prince Rupert was fought out. The battle has been described as one of bloodiest on UK soil and the estimated death toll stands at 4,300 people. Following the battle the bodies were thrown together in mass burial pits with no ceremony. People over the years have claimed to have witnessed blood-soaked soldiers, a headless horseman riding his steed and various men dressed in seventeenth-century clothing moving around the lanes surrounding the battlefield.

Crisis Apparitions

These spirits are possibly the worst ones that anyone could wish to witness. There are stories from people who claim to have seen their loved ones, who didn't acknowledge their relative when appearing to them, and getting a sense of dread at seeing one. These 'ghosts of the living' are portents that something dreadful has occurred to their loved one, who maybe many miles away. Some of these ghosts are witnessed at the moment of death, illness or injury and others are reported slightly later. In the 1953 book *Apparitions* by G. N. M Tyrell the author recounts a story of a woman who witnessed her brother's apparition standing in her kitchen, his back towards her, ropes around his legs and apparently falling forward. The witness, after seeing this shocking apparition, received a message shortly afterwards informing her that her brother had fallen overboard from the tugboat that he was working on and had drowned six hours before she had seen her brother's ghost.

Doppelgänger/Fetch

This type of spirit is probably the hardest for anyone to comprehend. The German word doppelgänger, which literally translates as 'double-goer', is an exact double, a spiritual replica, of a living person. To see one's own doppelgänger is believed to be a very bad sign of impending doom. Over the centuries there have been many famous people who claim to have seen their own doppelgängers including Queen Elizabeth I, Abraham Lincoln, Johann Wolfgang von Goethe and Catherine the Great, Empress of Russia, who after seeing her doppelgänger sitting on her throne ordered her troops to shoot at the spectre. Psychiatrists claim that seeing your doppelgänger may be a sign of schizophrenia. There is also another element to this type of spirit known as a bi-locational. This entity is a copy of an apparently alive and well individual. In the case of a bi-locational experience though it is claimed that both the living person and the duplicate are witnessed by multiple people and the two, the actual person and the copy, may actually be many miles apart.

Poltergeist

There are not many people in the world who have not heard of a poltergeist and they must potentially rank as one of the most famous types of paranormal phenomena. The word 'poltergeist' is a German word and translates as 'noisy ghost' and the name is a well-deserved one. This type of spirit is known for the distress and chaos

it causes. Events surrounding a poltergeist can include violent episodes of physical attack such as scratching, knocking and banging on walls and doors, disembodied voices, levitation of objects, including people, and general destruction of objects and furniture due to the spirit throwing items around the places they haunt. Fortunately for those who suffer a poltergeist infestation they are often short-lived events but their presence can have long-term effects on the mental health of those they haunt. One of the most famous cases of a poltergeist occurred at No. 284 Green Street in Enfield, North London from 1977 to 1979. The Hodgson family experienced a wide range of phenomena that focussed around their daughters, Margaret (thirteen) and Janet (eleven). The voice of the alleged entity was heard speaking through Janet in a gruff voice and claimed his name was 'Bill' and that he had lived in the house and died in a chair downstairs after suffering a brain haemorrhage. The case was investigated by Maurice Grosse (1919–2006) and Guy Lyon Playfair (1935–2018) of the Society of Psychical Research and also by Ed Warren (1926–2006) and his wife Lorraine (1927–2019) who were famed demonologists from the United States known for their work on cases such as the Amityville Haunting. The Enfield Poltergeist hasn't been without its critics and many believe the case to be a hoax. The haunting has given rise to a plethora of books, TV shows and films.

How to Use This Book

This book has been designed to ensure that you, the reader, have the easiest and most enjoyable reading format possible. Therefore it was apparent from an early stage that the best possible layout was to make *Paranormal Cornwall* an easy-to-follow A–Z guide. This means that finding the story you are particularly interested in is simple to locate. There is no need for an index as everything is listed in an A–Z format and allows you to pick up and put down the book as and when required. This is particularly useful when researching specific locations in general but also aides in reading the book cover to cover.

CHAPTER ONE

Bedruthan Steps, Bedruthan

Cornwall has many legends within its history and stories of giants feature strongly. The Bedruthan Steps were allegedly used by a giant named Bedruthan who used the rocks as stepping stones to cross the area between Park Head and Berryl's Point. Whereas the legends of giants elsewhere in Cornwall span back many centuries, this giant is somewhat of a relative newcomer. It's believed the story of the Bedruthan giant was created by locals in the nineteenth century to entice tourists to the area and enjoy the spectacular views across the Atlantic Ocean before them.

You won't see Bedruthan the Giant haunting this area. You may by chance witness some of the grey shadowy forms that are said to haunt this area but if you listen carefully, and if you're very lucky, you may just hear a strange phenomenon that is more commonly reported and thought to be associated with the ghosts of Bedruthan steps. Hush yourselves and listen for you may just hear a faint tap, tap, tapping sound apparently coming from nowhere. Where does this noise come from? What's creating these mysterious sounds? Those who are inclined to believe the more paranormal reasons for the sounds will tell you they are the sounds of the long-dead miners who used to work under the cliffs here and the tap, tap tapping sounds are the noises of their ethereal picks still striking the rocks deep underground.

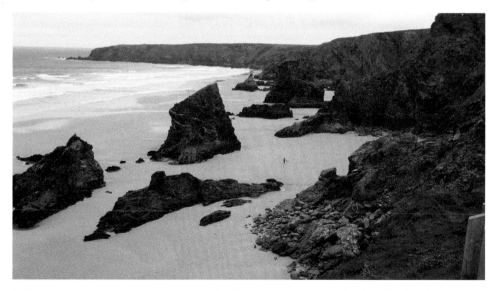

Bedruthan Steps, where the sounds of dead miners continue to be heard. (© Allen Watkin/ Bedruthan Steps/CC BY-SA 2.0)

CHAPTER TWO

Bodmin Jail, Bodmin

Bodmin Jail, sometimes called H. M. Prison Bodmin, Bodmin Gaol or the Cornwall County Jail, is certainly one haunted place that has risen to paranormal fame over the last few years.

Built in 1779 and designed by Sir John Call, the prison was based around the book *A Plan for a County Gaol* published by John Howard. The jail was considered to be a great leap in the ethical treatment of its prisoners and amongst many of the improvements constructed into the fabric of the building were such luxuries as running water in the courtyards, separate cells and living areas for male and female inmates, paid labour to the prisoners doing work and in general the jail was meant to be a light and airy place and thereby creating a healthier environment of incarceration.

Despite Bodmin Jail being constructed with all these new additions to improve the inmates' lives, it still didn't detract from the types of rogues and criminals that filed through the gateway en route to the cells, some of those prisoners eventually finding themselves hanging from the end of the hangman's noose.

The types of criminals that came to this jail included Elizabeth Commins, who killed her newborn baby after beating its head against its crib; Ethel Visick, who killed her child and disposed of its remains down a well; William Hampton, who murdered Emily Tredrea; Benjamin Ellison, who brutally murdered a one Mrs Seymour by beating her with an axe; Robert Brown, who killed his young apprentice boy by starving him to death; James Holman, who killed his own wife by caving her head in with a clothes iron before ramming his wife's head into an open fire; William Hocking, who was imprisoned and executed for bestiality; and Selina Wadge, who murdered her baby by drowning it down a well. But the most mysterious of all the jail's prisoners,

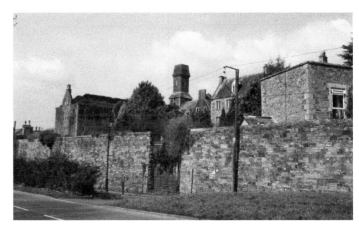

Bodmin Jail, where many a rogue spent their last night on earth before dangling from the end of the hangman's noose. (© David Scanlan)

in my most humble and honest opinion, must have been Anne Jeffries. Born in 1826, she rose to some prominence as many locals thought she had mystical powers and was in fact a changeling. On her incarceration she was sent into solitary confinement and was starved. The weird thing is that despite this horrendous method of torture she showed no ill effects at all. She did not become ill and she lost no weight. When she was questioned by the authorities as to how she could survive such harsh and barbaric treatment, Anne claimed that her well-being had been due to the fact that she was being cared for and fed by fairies who came to her cell every night.

During its functional use from 1779 to 1927, a part of which saw the Royal Navy commandeer a wing of the jail for its own nautical criminals, the jail was host to numerous executions on-site, so not only did the prisoners here have to deal with the misery of their imprisonment, some of them also had to deal with the thought of their inescapable and impending death.

When you take all the negative energy created by those listed above and then add to it yet more murderers, thieves, con merchants, sexual deviants, violent offenders and arsonists, it's hardly surprising that over the years their energy, their anguish, their mental imbalances and eventually their executions have left behind their own bitter-sweet imprints into this historical jail.

Over the years many people have investigated the ghosts of Bodmin Jail and many believe that not only have they encountered the ghosts of those who were formerly incarcerated, or indeed worked here, but there are those who say they can actually identify some of the ghosts that still roam this dark, dank old prison.

Probably the jail's best-known ghost is that of a gentleman known as George. He is believed to have been a former warden at the jail. The historical records do actually detail that at least three people employed over the years here were named George (I am sure there's probably more whose records of employment have been either lost or never recorded as the name of George would have been a common occurrence during the eras of the jail's use). This ghostly warden is said to have passed away whilst working at the jail after suffering from a heart attack.

The jail has a plethora of phantom inhabitants and I spoke to Mark Rablin, a professional psychic medium and energy therapist who leads the paranormal

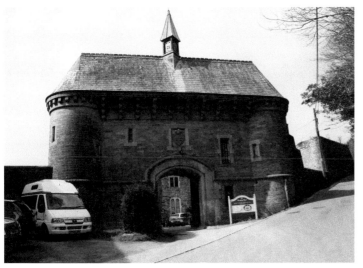

The entrance to Bodmin Jail, where many a prisoner passed through. On 16 August 1839 a prisoner named Thomas Werry was being led to the jail. When the gatehouse came into view the prisoner halted temporarily and when the guard turned to check on his prisoner, he was stunned to have seen that Thomas had swiftly managed to cut his own throat! Such must have been the fear that this jail imposed upon people. (© David Scanlan)

investigation nights that are frequently held at the jail. He told me that 'There is much activity in the jail as it's a big place. I host the events and have done for six years now, so over my time I have experienced physical contact, mists and a partial manifestation. I am a USUI Reiki Master/Teacher, so the world of spirit and indeed the world of the physical to me are all about energy resonating at different frequencies.'

Being a big place, I asked Mark where the most active parts of the jail would be? In his opinion he stated that he 'would have to say the basement (level 1) the long room (level 2) and my workshop floor (level 4), although there is a mix of activity on many levels. We have had reports of a full manifestation on level 3 and 4 and this was confirmed as Selina Wadge who was executed for the murder of her male child. Also we have the naval wing of the jail and that is good for physical contact and minor poltergeist activity (stone throwing). The basement has a good mix depending on the energy of the clients and we have a non-human entity (demon) resident down there and on more than one night have had physical contact and poltergeist activity centred around people's hats – they get knocked off their heads.' That must take a fair few paranormal enthusiasts by surprise I'm sure.

So now we know where the best places to experience the spooks and spectres of Bodmin Jail are, who is it we are likely to be encountering?

Well due to Mark' immense experience and knowledge of the jail he has been able to compile a list of what ghosts inhabit what particular areas and he told me that in the basement he has encountered the ghosts of Mary, Albert, Elizabeth and a non-human entity which he describes as demonic in form. This demonic form travels between the basement and level 5 via the stairway. In the long room (Level 2) the ghosts of James, George, Elizabeth, Sarah and The Children have been sensed and experienced on many occasions. Level 3 is the haunt (excuse the pun) of Selina Wadge, Matthew and Charlotte and level 4 is haunted by a female ghost known as Eliza. There are also

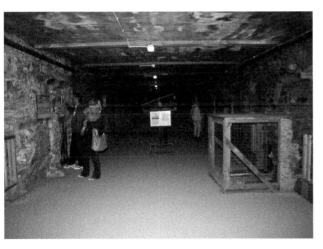

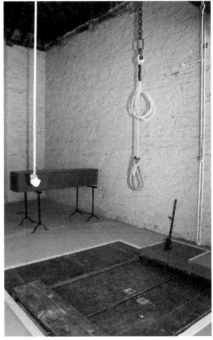

Above: The Long Room at Bodmin Jail, the area of many paranormal encounters. (© David Scanlan)

Right: The Execution Room (with a restored and fully working trapdoor) serves as a grim reminder of the fate of many of those who were imprisoned here. (© David Scanlan)

 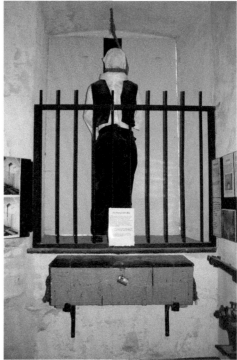

Above left: The Naval Wing of Bodmin Jail. (© David Scanlan)

Above right: The Hangman's Box at Bodmin Jail. The figurine waiting to be hung gives a certain sense of what a typical execution scene may have looked like but it is the green box at the bottom of the photo that is of most interest. This particular box is on loan to Bodmin Jail from Pentonville Prison, London. Originally it contained all the equipment used by an executioner and possibly held the ropes that saw John Ellis hang the notorious Dr Crippen for the murder of his wife in 1910. (© David Scanlan)

a further two ghosts on level 4 but their exact identity is still somewhat of a mystery, but Mark is certain one of them is a former jail guard and the other a monk.

The naval wing of the prison is said to be haunted by William Snowden, a gentleman known as Peter and finally the ghosts of the murdering brothers William and James Lightfoot who were hanged at Bodmin on 13 April 1840 for the murder of Nevill Norway.

'Looking at the list it seems we have a lot to work with on the nights, but I must say that they are not all around on a single night; a lot depends on the group and the way they interact with the jail and the spirits. An example would be James from the long room (level 2). If there was a young blonde in the group chances are James will be around as he likes young blondes and the first we would know about it would be when she screams and gurgles as James likes to strangle blonde women! Likewise, the children on level 2 like to hold hands and tug on trouser legs' said Mark.

I visited the jail on a relatively warm and sunny day. Soon after entering it became quite apparent what a dank, dark and dismal place this would have been for those imprisoned here and even more of a horrifying place for those waiting to meet their maker at the end of the hangman's noose.

Despite their crimes in life I hope the ghosts of Bodmin Jail eventually find peace.

CHAPTER THREE

Bodmin Moor, Bodmin

The next story I relate is probably one of the most famous stories of the paranormal to come from the historic county of Cornwall: The Beast of Bodmin Moor.

I must admit I was in two minds whether I should include the story of the Beast simply because of the reason that no one is sure what the Beast is. Ghost, cryptozoological oddity or a living big cat are the most common suggestions about the creature's existence and its presence on the moors.

Bodmin Moor is a classic wilderness. With the sunshine beating down on your face on a lovely summer's day the moor is a pleasure to walk. However, when the rain drives hard and the wind blows the moor quickly becomes a foreboding and desolate place. Starting around 1983 reports were received that visitors to the moor had witnessed a large black cat stalking the area, causing terror amongst those who had witnessed it. Farmers have reported finding slaughtered livestock whose demise has been blamed upon this phantom big cat.

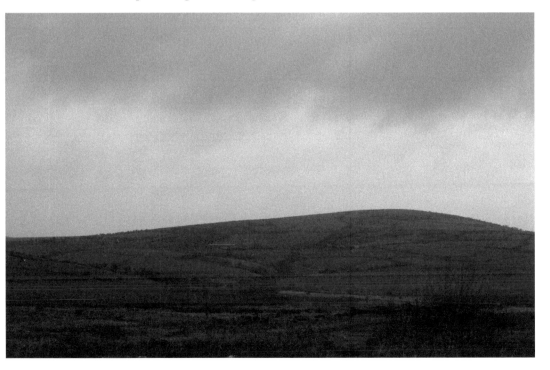

Bodmin Moor, where the Beast has been seen roaming. (© David Scanlan)

The amount of evidence for the Beast of Bodmin Moor is quite astounding. A simple internet search will turn up literally hundreds of websites, eye-witness testimonies, videos, photos and sketches of the Beast. However, we cannot be sure that the Beast is a ghost at all. For many centuries tales of supernatural black dogs – large dogs with glowing red eyes, often referred to as 'Hell Hounds' – have been found throughout British folklore and history. There are suggestions that as sightings of these 'Hell Hounds' have dwindled they have been replaced by sightings of big cats whose appearances are deemed more plausible due to the potential escape or release of former big cats in captivity. Indeed this isn't too far-fetched. In 1978 a Plymouth-based zoo, owned by famed circus trainer Mary Chipperfield (1938–2014), was forced to close. The five pumas based at the zoo were destined for a new home at the Dartmoor Wildlife Park in Devon, but only two arrived. It was claimed that Chipperfield had released three of the pumas into the wild, an accusation that her husband vehemently denies.

Others believe the Beast of Bodmin to be an unidentified, uncatalogued species of animal from folklore, similar to other mysterious creatures such as the Loch Ness Monster and Big Foot, which have so far evaded capture and study. Others still hold onto the belief that the Beast is an aggressive spirit that haunts the moors.

For me personally, considering the fact that other big cats in the UK, including ocelot, puma and lynx, have been captured or killed following escape and release, then the evidence at this stage points to the strong possibility that the Beast of Bodmin Moor is potentially a released puma. I feature this story in *Paranormal Cornwall* as the story of the mysterious big cat roaming the moors has been a significant one in the paranormal history of Cornwall for in excess of thirty years and I feel that it is now time to put to bed, once and for all, the paranormal connotations of these experiences, which have been reported by genuine witnesses. These phenomena are simply explainable and the Beast is nothing paranormal in origin.

Braddock Down, Braddock

On 19 January 1643 Sir Ralph Hopton, commander of the Royalist forces who were camped on Braddock Down, accidentally discovered a Parliamentarian force led by Commander Ruthin. The ensuing battle, which occurred more or less by accident and was not an arranged battle per se, resulted in a resounding victory for the Royalist forces. Ruthin decided not to wait for back-up forces and ordered the call to battle – a bad decision for the Parliamentarian army for not only was their army destroyed but the outcome of the battle also meant that Cornwall was brought firmly under the Royalist support banner.

Any battle equals death, sometimes on an epic scale, and death in these circumstances can lead to the presence of ghosts being left behind. But the ghosts that haunt here are not seen. Only heard. Although you will not see the ghosts of Braddock Down, you can time their auditory phenomena for they are known as a cyclical haunting: a haunting that returns at the same time and at the same place again and again, sometimes for many successive generations.

So, if you happen to be on the battlefield at Braddock Down on 19 January and you happen to hear the phantom footfalls of galloping horses please do let me know.

Bucket of Blood, Phillack

As soon as I drove through the small village of Phillack I stumbled across the quaint little public house known as the Bucket of Blood. With such a surprising and unusual name surely it must be haunted?

After meeting the staff, and downing a healthy glass or two of the local ale, the barmaid pointed me in the direction of a small piece of historical literature hanging

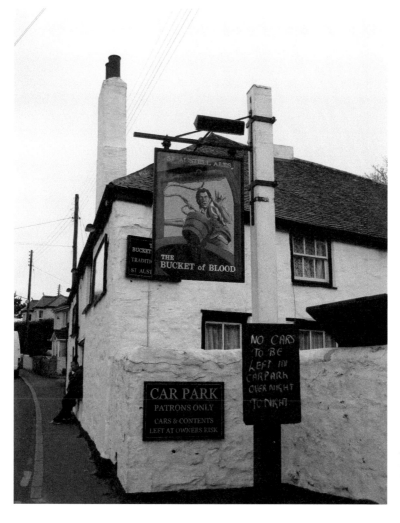

The Bucket of Blood in Phillack. (© David Scanlan)

upon their wall. I reproduce that article now and full acknowledgement to Phil Betteridge must be given for his detailed and entertaining story of the Bucket of Blood. It reads:

Centuries ago, before Hayle had been established, Phillack was a renowned port trading with the civilisations of Rome, Scandinavia and Phoenicia. From these early times there has been an inn on this site. Throughout the ages it has been the haven of miners, sailors, fishermen, pirates, smugglers and the ilk. A place catering for hard men in hard times. Life was cheap in those dark ages.

A deep well served as the only source of brackish water for the inn, water used not only for the needs of the household but also to brew the local strong ale. One morning the innkeeper went to collect his water, and drawing a bucket from deep down in the well, pulled up not water, but blood. A search found a corpse, badly mutilated. Who was he? Miner? Fisherman? Sailor from a far off land? Revenue man? We shall never know the truth.

A simple tale, and like most legends impossible to corroborate. But one thing still remains today. The inn is haunted. Late at night when all is quiet, footsteps can be heard walking across the creaking floorboards upstairs. Several people have seen ghostly figures crossing the road outside and then disappearing into the inn. Believe it or not as you please. Just remember that the landlord and most of the locals know it is true.

I am sure you will agree that this is a fantastic story to accompany an historical and haunted inn.

Chysauster Ancient Village, Newmill

I find the haunting of Chysauster Ancient Village fascinating. Not because of the experiences or reports people have had whilst visiting the village but mainly because of the age of the ghosts that are alleged to haunt here. They are amongst some of the oldest hauntings I have ever heard of or researched.

This ancient village was first occupied around 100 BC and was eventually abandoned by AD 300. This brief spell of 400 years of human occupation – and I say brief because some other locations have had continuous occupation for many hundreds and sometimes thousands of years – must have been significant for the past residents for they appear to have not moved on.

There are claims from witnesses who testify to seeing small grey figures moving around the ruins of the former Iron Age homesteads and many believe these phantom figures may well be the spirits of the people who first occupied this site over 2,000 years ago.

The remains of the Iron Age Chysauster ancient village. (© Adrian Farwell/Chysauster Ancient Village – Atmospheric and Overgrown/CC BY-SA 3.0)

Croft Pascoe Pool, Trelan

Close to Trelan and just across the Goonhilly Downs lies Croft Pascoe Pool. This small stretch of water has its very own ghost in the form of a lugger, a small type of local fishing vessel, which has been witnessed drifting across the pool. The author and scientist Robert Hunt (1807–87) wrote in his book *Popular Romances of the West of England* that 'Unbelieving people attributed the origin of the tradition to a white horse seen in a dim twilight standing in the shallow water; but this was indignantly rejected by the mass of the residents.' There are boundless stories of phantom sailing ships from around the world such as the *Flying Dutchman*, which has been witnessed numerous times, sailing the waters of the Cape of Good Hope in South Africa – so why shouldn't Cornwall have its very own little spectral boat?

Dead Man's Hut, Portreath

This small fishing village is home to a most bizarre little structure known as a Dead Man's Hut. The hut commands magnificent views across the sea and its construction was intended to have two main purposes:

1. To be used by the harbour master to watch ships and shipping in the area.
2. To serve as a temporary morgue for bodies that would have been washed ashore following shipping accidents.

Considering the rocky coastline of Cornwall and the fact that many a ship was destroyed by the sea and rocks here, it's fair to assume that this small building has contained many a corpse over the years. When those that had died in shipping accidents were washed ashore their bodies were collected and placed in the Dead Man's Hut. Relatives would come and view the bodies that had been gathered and take away their loved ones for a proper burial.

Over successive years many people claim to have seen a lonely figure standing in the Dead Man's Hut, looking out through the window towards the sea. Perhaps the ghost is that of a man whose body was temporarily laid here or maybe it's the ghost of a former harbour master still manning his post to ensure the safety of those traversing the cruel sea. Or maybe there's a more mundane and less exciting explanation.

In August 2010 Christian Adams, a Cornish paranormal enthusiast, decided to conduct an investigation of the hut in order to ascertain what spectral activity really was occurring. Christian said, 'I arrived at 21.45 and made my way along the harbour and up the steps to the hut. I climbed through the window and set up my equipment. I carried out a session of K-2 communication and a static test communication with no results.'

For those of you not familiar with paranormal investigation equipment or techniques then I should take a moment to explain what a K-2 communication session means. The K-2 meter is a small hand- held device that measures the levels of electromagnetic fluctuations in milliGauss (mG). The meter has a series of lights ranging from dark green through to red and the lights illuminate indicating at what level the current electromagnetic level is. A K-2 communication session involves placing the meter down onto a solid surface and then proceeding to ask a series of questions which beckon a yes or no response. Current paranormal thinking amongst many investigators of the supernatural states that when the resident ghost wants to answer a yes to the questions being asked then they will make the lights on the K-2 meter light up in quick succession.

Unfortunately, on this occasion Christian didn't obtain any evidence from his sessions with the K-2 meter despite running his experiments a total of three times in order to gain the most accurate results. He also attempted five Electronic Voice Phenomena experiments (EVP) without apparent results.

After experiencing nothing paranormal at the Dead Man's Hut and when departing Christian noticed something that could very well account for many of the sightings of the phantom man: 'When I was filming from a certain angle halfway down the stone steps leading to the hut it appeared to show a figure looking out of the window. This proved to be a trick of the light. The hut has two windows and a metal-gated doorway. It appeared that natural light would come through the larger of the two windows, hit the circled wall which would then make an image of a figure at the other window. This was a really good illusion; it nearly fooled me.'

Dockacre House, Launceston

The haunting of Dockacre House is one deeply rooted in a horrific murder.

In the early 1700s a married couple, Nicholas and Elizabeth Herle, came to live in the sixteenth-century five-gabled Elizabethan house and it is from this couple that our haunting originates from. In 1714 Elizabeth died in murderous circumstances when her husband shot her on the staircase of Dockacre House.

Elizabeth apparently went insane and her husband had her confined to a small room in the upstairs of the building. During her imprisonment it is rumoured that he starved her as this was considered a treatment of the insane in the 1700s.

Dockacre House, where the murder of a sick woman led to the haunting of the property by both the victim and the murderer. (© Roger Pyke/Launceston Then)

It appears that in December 1714 Elizabeth was able to escape from her home-made prison and flee. Whilst she fled down the staircase of Dockacre House, in a push to freedom, Nicholas is said to have drawn his gun and shot poor Elizabeth dead. For many years a bloodstained carpet marked the spot where Elizabeth met her mortal end and no matter how much it was cleaned the bloodstain would always return. This phenomenon has since ceased since the carpet was replaced. It doesn't appear that Nicholas was ever convicted of his crime as he twice held the title of Mayor of Launceston, in 1716 and again in 1721.

With a history of such a tragic event it is hardly surprising to discover the place is haunted. Some witnesses claim to have seen the ghost of Nicholas Herle moving through his former home in a somewhat unhappy state. He is also said to be seen playing a flute which usually heralds the death of someone in the house. There are also reports of people seeing the ghost of Elizabeth. She has been reported haunting the drawing room dressed in a grey dress and appears to be happy despite her unfortunate demise. Other occurrences in Dockacre House include unexplainable footsteps, doors opening and closing and knocks and bangs around various parts of the house and pictures flying off the walls! A milkman delivering milk in the 1970s also reported witnessing a gentleman wearing a wig standing in an upstairs window.

In closing this story there is still one final element that is unusual to the history of this house. As part of the sale of Dockacre House it is tradition that the old owner passes the new owner a walking stick. One of these walking sticks, of which there is at least thirteen in the collection, is said to have originally been a flute owned the damned Nicholas Herle.

CHAPTER TEN

Dolphin Inn, Penzance

As soon as you enter Penzance it immediately becomes clear that this town was built for ships and shipping. Its harbour gently cradles the small boats that many a fisherman use on a day-to-day basis. The gift shops selling shells and other nautical memorabilia adorn various areas around Penzance. Close to the harbour stands the Dolphin Inn public house.

The Dolphin has quite a reputation, both in its history and in its paranormal legends. Stories are rife of smuggling in the area and indeed it's claimed that there

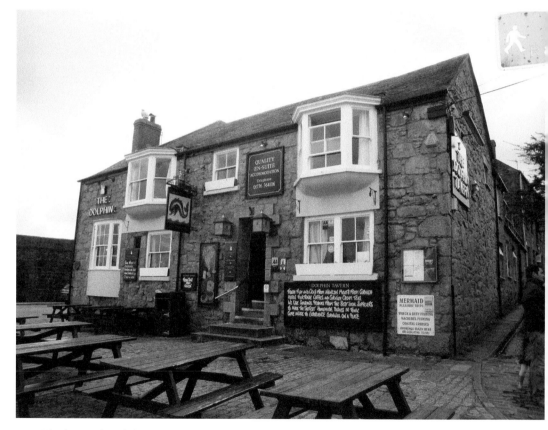

The haunted Dolphin Inn public house in Penzance, home to at least three ghosts and a wealth of fascinating history. (© David Scanlan)

are a series of underground tunnels in which the smugglers from times gone by used to move their contraband around. A few years back some old casks for holding alcohol were discovered in a sealed-up room which may attain to the pub's nefarious connections of yesteryear. In 1585 Rear Admiral John Hawkins organised the Cornish response to the impending Spanish Armada. John had a quite a reputation in his day as a trader, both in goods and in the slave trade. His second cousin was the famous Sir Francis Drake and John's family carried a certain element of royal favour. John is also accredited for the first imports of potatoes and tobacco to England. It's also claimed that the first pipe smoked in England was actually smoked in the Dolphin by Sir Walter Raleigh. Now ... how's that for a piece of history!

With a history that encompasses war, smuggling, shipping and trade, the Dolphin is bound to have picked up a ghost or two. The ghosts at the pub are well known and they make themselves known to the living not only by appearing to them but also by producing feelings of being watched, making dragging sounds – possibly the sounds of them moving their heavy contraband – and footsteps that no one can explain.

The most famous of the Dolphin's ghosts is that of an old seaman. Perhaps he is a former sea captain, an ordinary crew member or maybe even the wraith of a former smuggler or pirate. When he is witnessed those seeing him describe him as being dressed in the traditional style of tricorn hat and a jacket adorned with brass buttons and lace ruffles.

Our second ghost is that of a woman who appears in a Victorian style of dress. She is renowned for appearing in the main public bar area and has been witnessed walking into the solid stone wall. The final ghost haunting the Dolphin is usually witnessed in the cellar of the pub. Members of staff working here have reported seeing the apparition of a man with very blonde hair in the cellar and when they go to tell other staff members about the would-be intruder he cannot be found anywhere in the vicinity.

Dozmary Pool, Bolventor

You will remember in the introduction to this book I wrote 'I have only tried to relate aspects of ghosts, phantoms, spooks and spectres in the pages that follow. I have had to, sadly, omit the fantastic legends of King Arthur and the many, many intriguing myths and legends that go into making the county of Cornwall', but there are some venues that carry not only mythical connections but also spooky connections as well. Dozmary Pool is one such venue that I simply could not pass by without a mention.

Dozmary Pool is quite easily missed if you don't know what you're looking for, despite the pool being signposted from the nearby Jamaica Inn. The pool – it's actually

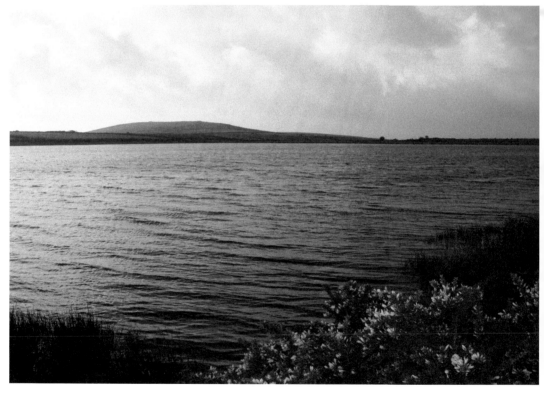

Dozmary. A lake easily missed but one that is so important to British history, tradition and folklore that it should not be passed by. (© Summer Scanlan)

a lake by the way – covers approximately 37 acres and is nestled on Bodmin Moor. It is famous for being intrinsically linked to British tradition for it is here that the Knight Bedivere returned Excalibur to the mystical Lady of the Lake when King Arthur lay dying following his defeat at the Battle of Camlann, Slaughterbridge, in the sixth century.

In addition to the pool's associations with good King Arthur there is also the legend of Jan Tregeagle. Jan was a local magistrate in the 1600s, a magistrate with a less-than-decent reputation. It is said that Jan Tregeagle entered into a pact with the Devil: the Devil would get Tregeagle's soul in exchange for power and success. Following his death a court case was taking place where the defendant had made an illegal claim to some land. The defendant was so sure he would win the case that he stunned the court by stating 'If Tregeagle ever saw it, I wish to God he would come and declare it!'. The defendant was trying his luck. Calling the dead to witness … surely this could never happen? But happen it did and you can imagine the court's utter surprise when the ghost of Jan Tregeagle took to the stand to give his evidence. After being honest at the trial the people of the court felt they could no longer condemn him to Hell, so they decided to set him a series of impossible tasks. One of these tasks was to drain Dozmary Pool with nothing more than a limpet shell with a hole in it. Tregeagle didn't quite fancy that task, so escaped to Roche Rock, although some stories actually claim Tregeagle was chased to the rock by a pack of headless hell hounds, where the task of weaving ropes from the sands at Gwenor Cove was set to him. Perhaps it's the ghost of Jan Tregeagle who has been witnessed lurking amongst the ruins of Roche Rock to this day? People also say you can hear the moans of Jan Tregeagle echoing out from across the bleak moors, or maybe that's just the sounds of the farmer's sheep!

Finnygook Inn, Crafthole

The website of this delightful inn proudly states 'The Finnygook is a 15th century coaching Inn located close to the South West Coast Path in Cornwall with stunning views across the Lynher and Tamar rivers. It was completely renovated in October 2009, and with no pool tables or fruit machines, you can enjoy a real log fire and eat out in comfort or perhaps just enjoy a pint of real ale and read the local newspapers.'

Many historical places are haunted and therefore it makes sense that this inn should have a ghost ... and indeed it does! The ghost of Silas Finny has often been remarked upon and is said to haunt the Finnygook Inn, a place bearing his namesake – but what's his story?

Silas Finny was a smuggler in the 1700s and is said to have used the area around Whitsand Bay for his nefarious activities. On one particular occasion it seems Silas had a disagreement with some fellow smugglers about the split of the recent illegal import they were going to bring ashore at Whitsand Bay. Feeling a little malicious, Finny decided to inform the local authorities about his colleagues' illegal smuggling activities. They were promptly arrested, tried and sent to the penal colonies in Australia.

Sometime after this occurred the body of Silas Finny was discovered on a hillside between Crafthole and Portwrinkle. He had been murdered and many people believe he was killed because of his treacherous actions against his fellow smugglers.

People to this day say his spirit wanders the area of his murder and haunts the Finnygook Inn. You will probably be saying at this stage 'Ok. I get the Finny bit from the Finnygook Inn's name. What's a gook?' And a fair question it would be too. A simple question begs a simple answer. Gook is the old Cornish word for ghost. Therefore you could also call the Finnygook Inn the Finny Ghost Inn.

CHAPTER THIRTEEN

Forrabury, Boscastle

If you stand, look and listen out towards the open sea you may well hear the sounds of phantom bells drifting in to shore from beneath the waves. Legend tell us that a ship was bringing church bells to shore when the tide changed and the vessel had to moor up as it could not enter Boscastle harbour. The ship's captain prayed for safe passage but was mocked by a fellow sailor. His blasphemy caused a storm to erupt and the vessel was sunk, bells and sailors were swallowed by the sea and the only survivor was the pious captain. To this day people claim to hear the sounds of bells coming from the waves and some even believe they have seen people in rowing boats struggling to reach the shore.

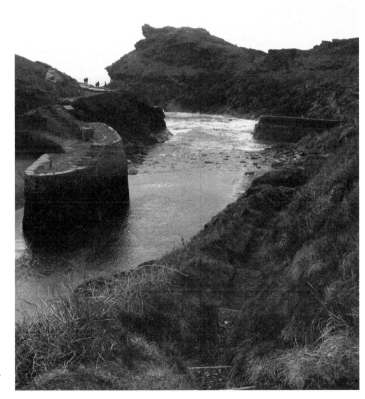

The entrance to Boscastle Harbour. Forrabury is where you may be lucky enough to hear the phantom church bells ringing from beneath the waves. (© David Scanlan)

Gibraltar Square, Stratton

During the writing of this book I came across a lady, whom although known to me wishes to remain anonymous, who told me about a house she used to live in that she believed to be haunted.

She told me, 'We moved there in January 1988 when my youngest boy was just two years. old. The house itself dated back to the mid-fifteenth century with additions to it added on through the years. It was a lovely old place and a Grade II listed property.

The previous owner told us about things that had happened there and that there was supposed to be the ghost of a nun that visited, though I can't quite remember if she'd experienced anything herself. It seems that way back in time legend had it that there was a tunnel from the middle room downstairs over to the church, which wasn't that far away from the building. Whether this was true I've no idea as we couldn't find anything. The previous owners told her they had had the feeling of a woman brushing passed them on the stairs and when the wife had opened the smallest of the bedroom doors one day, she had seen a closed coffin in there. She shut the door and then opened it again and the coffin was gone.

We had the usual strange occurrences of doors opening themselves and the smell of wonderful flowery perfume which frightened the life out of a friend of mine when she came to stay. But it was our son that actually saw the ghost of the nun. He'd spoken to his brother and girlfriend about the lady in his room once when they were babysitting but they couldn't find anything. It didn't seem to bother him at all. Then one day we were watching the film *The Blues Brothers* and when the part came on showing a nun standing at the top of some stairs my son turned to me and said, "That's like the lady I see." The only other spiritual thing that happened there occurred after my father, who had been living with us, passed away. He'd often laughed at what I'd tell Mum of my experiences at the Spiritual Church I'd attended in Rushden where we used to live. Anyway, the evening of his passing, my husband had to go out whilst I waited in for the vicar, who was coming round to see me. As he went out of the front door he noticed that all the wall lights in what had been Dad's room were on. I know that I'd not been in the room and nor had anyone else since Dad's body had been removed but low and behold they were on. The next thing happened after the funeral. I must say now that our middle son is a great one for jokes, and at first we blamed him but realised that he couldn't have done it.

Two days after the funeral I was woken up just after midnight by music. It was coming from downstairs. My husband had put Dad's room back to what it had been, our dining room; he'd also put his new radio/cassette player in there as well. When I went down the radio was blaring out with music but when I looked it was on the

cassette setting. Nothing else happened for a few weeks. Then again I was woken by music. By this time the radio/cassette player was in our upstairs living room and again it was blaring out. Roger looked at me and then the penny dropped: Dad. I got out of bed, went into the living room, put the light on and walked over and turned the radio off. Then I turned round and said, "Okay Dad, you've made your point that I was right about life after death. I don't mind you coming back at all, but could you make it during the day please." After that all was peaceful. I truly believe that that's what it was: Dad had not been a believer but he just wanted me to know that I was right.'

I think you'll agree with me that this story is a great overlap of a characteristic-style haunting what with the spectral nun making her presence known and what a fantastic addition to have the visitation of a newly passed-on spirit coming back to visit. Due to this property currently being lived in I have decided not to reveal the exact venue to avoid causing any distress to any current occupants, but should you live in Gibraltar Square in Stratton and suspect this could be your property and you're experiencing phenomena you can't explain then please do contact me via the publishers.

Godolphin House, Godolphin Cross

This lovely seventeenth-century mansion built in the Tudor and Stuart style is well worth a visit if you're in the area. The house is open on selected days so check the National Trust website for the latest opening times at www.nationaltrust.org.uk/Godolphin. In addition to the house the estate boasts an early formal garden dating from around 1500 and Elizabethan stables. The surrounding area is also home to the former Godolphin mines, whose founding here has left a very unique-looking landscape.

The house and grounds are home to a collection of different spooks and spectres. If you should witness a man dressed in old-fashioned garb, looking out from the windows then you may very well be looking upon the spirit of King Charles II. The king, a prince at the time when he resided at Godolphin, stayed at the house whilst the restoration of the monarchy was underway. Leading from the house to the nearby chapel you may be lucky enough to witness the funeral procession of Lady Margaret Godolphin (née Blagge) which appears on or around 9 September every year, the anniversary of her death during childbirth.

Margaret married into the Godolphin family in 1675 but she never visited the house in life. Before her passing 1678 she requested that she be laid to rest at the mansion. If you're going to visit the mansion in the hope of seeing the funeral procession then you may have to be flexible in your arrangements. Although she died on 9 September it took around two weeks to transport her mortal remains back to Godolphin, so just bear that in mind as the exact date of her funeral procession could have a two-week delay. But don't fret; you don't have to continually visit the house every day and night for two weeks in the hope of seeing the ghost of Margaret, also known as the White Lady, as the house is available to hire outside of its normal opening hours. Why not spend a week or two sleeping in a real haunted house … if you're brave enough of course!

Godolphin House could very well be one of the spectral homes of King Charles II. (© David Hawgood/Picnic tables at Godolphin House/CC BY-SA 2.0)

Hell's Mouth, Gwithian

Stand upon the edge of the 275-foot-high cliffs that are known today as Hell's Mouth and one thing becomes very apparent: if you fall from here you are very much dead!

A story from the area tells about a local criminal who entered into precarious dealings with a friend of his and when his friend was arrested, he thought it best to lay low and hide out for a few months. When the law enforcement agencies were no longer hot on his tail and were more occupied with catching the bigger smugglers, wreckers and criminals of the day, the gentleman returned to the area he knew so well. But something had changed. When he arrived home, expecting to rest his head and be met by the warm loving care of his sister, he found nothing but his former home burnt to the ground and the body of his murdered sister.

Coming face to face with such a distressing sight the man ran to Hell's Mouth. Realising he had lost all that he had known and loved he threw himself onto the furious rocks and raging sea.

When the waves crash violently upon the rocks and the wind is strong and bitterly cold people say you can hear the sounds of the man's cries as he plummets to his death. In Peter Underwood's book the *Ghosts of Cornwall* he reports that some years ago a group of mining students who were camped in the area of Hell's Mouth stated that they had heard 'fierce yells and snatches of old sea shanties echoing from the caves and tunnels' coming from below the inaccessible and deadly cliffs.

Hell's Mouth in Gwithian. An area where many troubled souls over the years have chosen to end their life by leaping from the cliffs. (© David Scanlan)

Irish Lady Rock, Sennen Cove

Many a ghost has come down to us this day because of moments of terror and the fact that those people who remain behind as ghosts passed away, usually, in tragic and frightening circumstances. Therefore pay special attention should you visit Irish Lady Rock, near Cowloe Rock, in Sennen Cove for you may just come across one such ghost. It is said that a boat sank in the area and a woman who had survived the initial sinking managed to cling to the rock whilst she waited to be rescued. Sadly, the rescuers came too late and she slipped into the sea and died. Since her death people have said that on occasion you can see the ghost of this poor unfortunate lady still clinging to the rock waiting to be rescued.

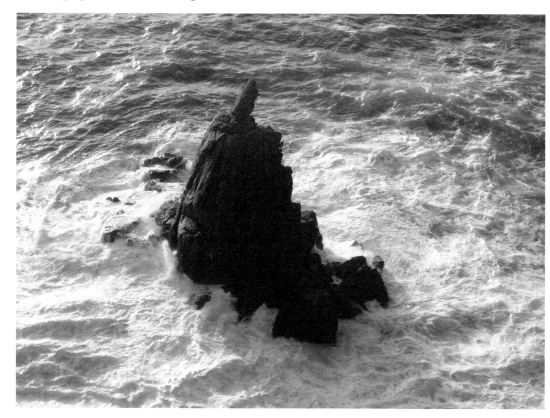

Irish Lady Rock in Sennen Cove, where the phantom of a dying woman has been sighted. (© Andrew Bone/Irish Lady Rock/CC BY-SA 2.0)

Jamaica Inn, Bodmin

Whenever you mention ghosts or haunted houses in the county of Cornwall then the shout of 'you must go to the Jamaica Inn to see a ghost' is a commonplace reply to your enquiries.

There can be little doubt that the Jamaica Inn is one of Cornwall's most famous haunted venues. It first reached the public attention in 1936 when famous author and novelist Daphne Du Maurier stopped here. It is said she was out horse riding on the moors when the weather took a turn for the worse and she took shelter in the inn. Here she was regaled with ghost stories galore by the local reverend, a figure that was to become the Vicar of Altarnun in the book by Du Maurier.

The inn was built in 1750 and was extended in 1778. It takes its name from the local Trelawney family who were governors on the island of Jamaica in the 1700s. It was once, long ago, the haunt of many a smuggler, vagabond, murderer and wrecker but is now a welcoming hostelry that boasts an on-site museum dedicated to the history of smuggling, thirty-six en suite bedrooms, a fantastic restaurant and, of course, a high-quality bar.

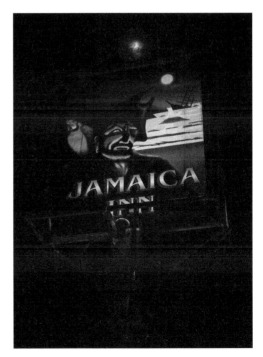

The Jamaica Inn's sign sits proudly outside the building. Creaking eerily in the wind, it is nearly as famous as the inn itself.
(© David Scanlan)

Its ghosts and legends are well known. From the phantom clattering of a horse and carriage that is heard rolling across the cobblestone courtyard to the ghost of a lady of the night. The lady, who was said to have used the rooms at the inn, became pregnant by what was thought to be a local gentleman of high standing in the community – some comment that this man was a local Member of Parliament or maybe even a local magistrate, but no one knows for sure. The woman gave birth to a healthy child and the babe's father grew concerned that his activities with such a disreputable lady might reach the ears of the locals. It is said that he paid the landlord of the Jamaica Inn to kill both the woman and his bastard child. From this time onwards people claim to have witnessed the ghosts of a woman and her baby – some say the child is as old as seven or eight – appearing at the sides and foot of their beds when they sleep in Room 5. The woman and her child then walk through the wall where the mirror is. Was Room 5 the room where she gave birth? Was it the room where she and the gentleman's illicit liaisons took place? Or was it the room in which the lady and her babe were cruelly slaughtered? To this day people staying in the room leave behind a wide variety of toys, dolls, music boxes and even letters addressed to the little girl, who has become known to staff and guests as Hannah. Most of the letters are similar in vain, wishing the spirit of the deceased girl love, light, peace and happiness, although one of the letters I read had a more berating tone. The letter, which is anonymous and dated May 2016, reads as follows:

Dear Hannah,

I'm not sure what we did to offend you so, but nothing could warrant your treatment of us. The flickering lights, your footsteps on the creaking floorboards and the ashen face in the mirror will continue to haunt me long after I have left room 5.

Instead of leaving you a present, as many have before us, we will leave the future visitors a piece of advice;

DON'T FALL ASLEEP …

Another ghost said to frequent the inn is that of a man dressed in a tricorn hat and a long green coat who has been witnessed walking through locked doors and also appearing in the guests' bedrooms. In 2004 the popular paranormal investigation TV show *Most Haunted* visited the inn in the hope of bringing about some sort of conclusion to the sightings. The show's medium, Derek Acorah, known personally to the author, used his mediumistic ability to 'lock on' to this phantom and obtain a name. That name was Jack Trevellis. To date no record of a Jack Trevellis has been found to support Mr Acorah's claim, but who knows what future research will bring to light.

Our final ghost at the inn, and the most famous of the inn's collection, is a man whose name is lost to history. Its claimed that in the 1700s a young smuggler who was drinking his ale at the Jamaica Inn was called outside, perhaps to conduct some illegal bargain or deal. The man never returned to the inn and his corpse was found the following day on the moor. Since the man's murder his ghost has

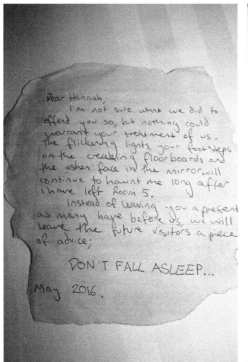

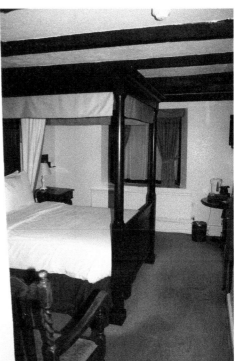

Above left: The warning letter left by one guest who stayed in Room 5 in 2016. (© David Scanlan)

Above right: The haunted Room 5 at the Jamaica Inn. Are you brave enough to spend the night in this bedroom with the spectre of Hannah? (© Summer Scanlan)

Right: A selection of gifts that guests have left in the wardrobe of Room 5 in the hope of pleasing the spirit of Hannah. (© Summer Scanlan)

been seen sitting on the wall outside the Jamaica Inn and also lurking around the car park.

All these hauntings surrounding the Jamaica Inn show that it was obviously an important stopping-off point for me in the writing of this book, and as is usual in my previous books, I always like to showcase and promote the work of local and national paranormal investigation groups who have conducted the most recent investigations at the haunted places I write about. Therefore you can imagine my sheer joy when not only would one of the groups, who have probably frequented the inn more than any other, not only openly invite me to interview them but also invited me to attend one

A selection of letters that guests have written to Hannah. Most are gracious and loving although the occasional one or two do complain of Hannah's shenanigans in the middle of the night. (© David Scanlan)

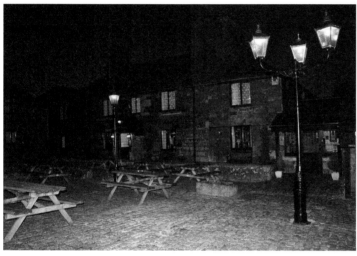

The courtyard of the Jamaica Inn. (© David Scanlan)

of their investigations at the Jamaica Inn! Would the night reveal some of the ghostly residents?

On 7 April 2012 I arrived at the inn with my good friend and fellow paranormal investigator with the Hampshire Ghost Club Rich Atkin. We quickly met the team of Haunted Happenings (www.hauntedhappenings.co.uk) who were to run the investigation at the Jamaica Inn: Martyn Boyes, Paul Dutton and Ron Teskowski. They told me their investigation group was founded in 2007 with their first investigation taking place in 2008. In the five years they have been established they have run and conducted in excess of 1,000 investigations including studies at famous venues such as Lincoln Prison, Pendle Hill, Woodchester Mansion, Tutbury Castle and Warwick Castle to name but a few. This investigation was to be their fifteenth investigation of the Jamaica Inn!

Martyn and Paul told me that during the course of their investigations at the inn they think they may have stumbled across more ghosts than was initially first thought. 'We think we have discovered at least three more spirits roaming around the inn. One is a malevolent spirit of a man who is very aggressive and the other two are

The courtyard of the
Jamaica Inn, where the
phantom sounds of the
Coach and Horse
are still reported.
(© David Scanlan)

children; they have given their names as Helen or Elena and Tom and both appear to be around the age of seven or eight.' Could these be associated with the earlier story of the murdered prostitute and her child? Could the malevolent spirit be the ghost renowned for wearing a tricorn hat and long green coat? I asked. 'We're not sure just yet. We need to get more evidence we can check out before we state that', was the reply. Hopefully further information and evidence will be forthcoming.

'So what experiences have the Haunted Happenings team had here' I enquired?

'We get a lot of our guests complaining of headaches, nausea, pressure, feelings of being watched and a general sense of uneasiness at times'. These are quite commonplace experiences that are reported frequently in haunted places, so I pressed for further, more tangible physical evidence that has been experienced. I was not to be disappointed.

'Physical experiences here include mobiles phones being switched on even though they have been turned off and won't come on accidently. Recently a husband and wife team on our investigation here were outside the inn having a cigarette break when all of a sudden the woman's phone went off and she had received a text message from her husband saying "I won't do it", yet his phone was turned off and he showed us it was off. He powered up his phone and then showed us his text message sent file which clearly showed he had not sent any text of that nature to his wife or anyone else. The Haunted Happening director, Hazel Ford, was staying in Room 3 one night when she clearly watched the bedroom door open and close completely by its own. TV sets switching themselves on and off and objects moving around are all commonplace as well.'

After the interview ended the investigation got into full swing. We were treated to the story of a recent eye-witness account surrounding Room 6. Paul told us that a woman and her daughter were staying in the room when, in the middle of the night, they heard the loft hatch door located in their en suite bathroom sounding like it was being opened. They entered the bathroom to find out what was going on and were shocked to come face to face with the ghost of a man standing in the bath.

Paul said that on a past investigation they had opened the wardrobe as they had heard the sound of the clothes hangers being moved around and instantly noticed that a blanket that was stored in the wardrobe had a large man's handprint imbedded

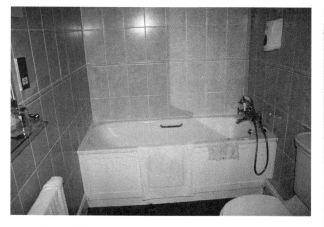

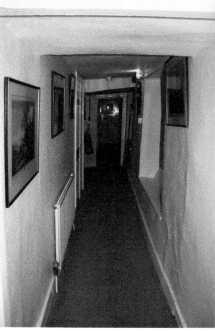

Above: The bathroom of Room 6, where a lady and her daughter witnessed a most unexpected guest. (© David Scanlan)

Right: The atmospheric corridors of the Jamaica Inn can certainly make you feel on edge but do spirits of the past really still walk these corridors? (© David Scanlan)

upon it. Despite trying to match the handprint to the guests no match could be found. The Haunted Happenings team have subsequently been told that from time to time the cleaners report finding the same mysterious handprint imbedded in the blanket! After the guests had left, myself and Rich hung back and spent some time in the room on our own. After a short period the sounds of what sounded like someone moving lightly about the room started to raise our awareness that we might not be alone. After another short period both of us clearly heard the sound of the clothes hangers being moved gently in the wardrobe but alas no handprint was to be discovered on this occasion.

One of the most fascinating areas of the inn, in my opinion, is the smugglers museum. The museum used to be the inn's stable block but it has not housed horses for decades and for some strange reason, even though the museum has been used for a variety of uses including that of a restaurant, the stale smell of ages old horses cannot be got rid of. Contained within the museum is a variety of displays showcasing various elements of smuggling history and Daphne Du Maurier. One of these exhibits is that of an ornamental elephant. This elephant is an apparent favourite of the children's spirits that haunt this particular area and its claimed that on one occasion the Haunted Happenings team discovered a small child's handprint on the inside of the glass casing. How the handprint came to be there has yet to be explained.

The museum has a strange feeling to it, like something is about to happen or as if someone is watching and waiting. So it was obvious that this was a place Rich and I would like to spend more time in ... alone!

Ron Teskowski, a team leader with the Haunted Happenings group, placed one of us at one end of the museum and the other at the other end. He placed a sweet in our hands and one on top of our heads and asked for the spirits of the children they believe they have contacted previously to step forward and knock the sweets from

our hands. After a few minutes Rich Atkin reported that his sweet had rolled a few centimetres without explanation. Mine on the other hand had been forcibly thrown to the floor!

Replacing the sweets back into our hands and asking for the experiment to be repeated was the next step. This time there was a slight change. Ron asked the spirits of the children to not only move the sweets but to also unwrap the sweets. Again, a few minutes passed and the sweets rolled a little, for both myself and Rich; after a few seconds more I could clearly hear the sound of the sweet wrapper being gently touched, the plastic wrapper crinkling and crackling in my hand without apparent explanation!

Although we experienced nothing else during our time with the Haunted Happenings team the movement of the sweets and the sounds of the wrapper being gently tweaked is something both myself and Rich will remember for many years to come in what is now known to us as the 'sweet incident' of the Jamaica Inn.

I returned to the Jamaica Inn on 31 January 2020 and after a peaceful and uneventful night I awoke early in the morning and started to load the car up ready for the return trip home. I went to enter the hotel entrance and looked around at the smugglers museum. I was completely taken aback to witness the sudden appearance of an apparition. The figure was around 5' 6" in height, completely black with no features other than a human body shape, which ran from the window of the smugglers museum towards the Jamaica Inn sign, promptly vanishing from sight when halfway between the museum and the sign. The sun had risen and the weather was good. There was no mistaking this ghost and I couldn't find an explanation for what I had seen.

The Smugglers Museum at the Jamaica Inn, home to an interesting exhibition and the 'sweet incident'. (© David Scanlan)

CHAPTER NINETEEN

Jew's Lane, Godolphin Cross, Helston

There is a story from this area of a Jewish man who sadly committed suicide by hanging himself from some nearby trees. Religious traditions usually stated in past times that those who took their own lives were not permitted to be buried in consecrated grounds and their mortal remains were usually interred at crossroads, a deliberate act thought to confuse the spirit of the dead and designed to leave the spirit in a state of feeling lost and in turmoil. Thankfully this is now a past tradition and those who take their own life are permitted to be buried where their loved ones choose.

The ghost seen in this area is, as you may suspect, the ghost of the Jewish man. However, there appears to be an apparent strangeness to this tale as the legends tell us that this man does not appear in human form but is witnessed as a large bull. How he has been able to achieve the transition from a human soul to that of an animal is somewhat of a mystery. Most serious ghost hunters these days consider this story to be part fact and part fiction, e.g. someone did commit suicide in the area many years ago, but they also feel the story of the phantom bull has become more of a myth than a true ghost sighting these days. If you're looking for a real paranormal encounter then I would suggest avoiding this area and tracking down one of the much more plausible ghosts, spooks or spectres mentioned elsewhere in this book.

Jolly Sailor Inn, Looe

This sixteenth-century pub, sometimes called the Ye Olde Jolly Sailor, not only boasts to be one of the oldest public houses in the UK but also has the presence of three ghosts inside its historical walls and one outside.

There have been sightings over the years of a former coachman who has been described as having his hair up in a ponytail and wearing a ruff-style shirt. The ghost of a young girl and also the ghost of a short lady wandering about the pub have also been reported.

I spoke to Christine, a current employee at the pub for seven years, and she told me that 'a couple of years ago the ghost of an old woman wearing an old-style dress was seen going from the ladies' toilets and heading towards the kitchen', but she also admits 'I've never seen anything here myself though, but we have mediums come into the pub from time to time and they always comment they can see this ghost or that ghost sitting around the bar.'

There is also a legend stating the spirit of a young local girl who killed herself has been seen at the door of the Jolly Sailor, but not in human form but in that of a white hare. Be sure to check out www.jollysailorlooe.co.uk when you are in the area and should you be partaking of one the pub's fine cask ales or enjoying a meal then make sure you keep an eye out for their spectral inhabitants. Most ghosts seem to pop up when you least expect them!

Kennall Vale, Ponsanooth

If you take a delightful ramble through the woodlands of Kennall Vale, currently administered by the Cornwall Wildlife Trust, you will come across the odd decaying building amongst the 8 hectares of wildlife reserve here. These dilapidated structures are from a time when Kennall Vale had a completely different use.

In the 1830s the area was used for the production of gunpowder that was utilised in the mines of Cornwall. The mills here, powered by steam from the flowing waters that pass through this area, used coal. It doesn't take a rocket scientist to work out that burning a combustible material like coal around a product that you are manufacturing that's whole purpose is to cause explosions isn't a particularly great idea.

Eventually the inevitable happened. In May 1838 a sudden and unexpected explosion in one of the mills here caused a catastrophic chain reaction and five of the buildings were destroyed by horrific explosions. Virtually all the workers survived, surprisingly, except one poor gentleman, a one William Dunston who left behind a widow and ten children. Legends state that the only thing of poor old Dunston that was found intact was his head.

Since that time the spirit of William Dunston has been seen wandering the area of the woods and his former workplace. Perhaps he is hoping a passer-by will tell him what happened all those years ago and he can finally move on. Until that happens I fear the ghost of William is doomed to walk these woods and the old mills that suddenly and sadly took his life away from him.

CHAPTER TWENTY-TWO

King's Head Public House, Altarnun

The King's Head public house in Altarnun dates to the early seventeenth century and is one of the oldest inn's on Bodmin Moor. Throughout its long history one would expect it to pick up the occasional ghost and indeed it has. The ghost of a former landlady from the 1700s, known as Peggy Bray, is said to haunt this aged former coaching inn and she makes her presence known by appearing to the surprised guests as she casually walks the hallway of the first floor. In 2011 a team of four intrepid ghost hunters braved an all-night investigation at the pub. At around 3 a.m. the team decided they couldn't stay awake any longer and retired to their beds, leaving their recording equipment in situ. The team were stunned to find, when reviewing their evidence the next day, that at 3.20 in the morning the sounds of footsteps crossing the carpeted bedroom floor of Room 3 had been caught on tape. The room had no occupants that night and beside that how could the sound of heavy footsteps be recorded upon a carpeted floor! Other recordings on the night included the sounds of an old-style latch being rattled and an unusual clicking noise that seemed to have no known origin.

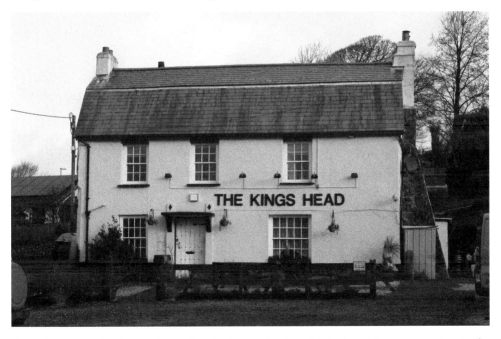

Does the spirit of a former landlady still haunt the King's Head in Altarnun, putting in the occasional appearance and rattling door latches as she goes? (© David Scanlan)

Land's End Beach, Land's End

If you happen to be exploring the beach and cove around Land's End and stumble across something that resembles ivory then I would advise you to leave well alone!

There is a story that many centuries ago a Chinese princess was sent to England to deliver a special consignment: a pair of Pekinese dogs. The dogs were transported in an ivory chest to ensure their safety. These dogs were highly valued in China and therefore only members of the royal Chinese family were permitted to own the dogs. During the trip a storm is said to have suddenly whipped up and the sailors, fearful for their lives, became convinced that the Chinese princess, a stranger from foreign lands, must have been the cause of it. They decided that there was only one thing they could do to survive the storm: caste the hapless princess and her dogs into the freezing Cornish water. As a sailor attacked the princess her faithful pooch bit the sailor and he was said to have died shortly after, but not before throwing the two dogs and their ivory chest into the water behind the princess. Dying from a dog bite of this nature is in itself an amazing feat considering the small stature of the Pekinese breed.

Eventually the body of the princess was washed up and so was the ivory chest containing the dogs. Locals found the princess and the ivory chest on the beach and opened the lid of the chest, probably thinking some valuable treasure lay within. Instead, they came face to face with a half-dead dog who died shortly after. The princess and the ivory chest containing the carcases of her once loved pets were buried on the beach around Land's End. Legends persist to this day that people who have gone treasure hunting in the hope of finding the ivory chest have mysteriously been bitten by the teeth of the phantom hound that now haunts the beach where it died.

Land's End. Somewhere along this shoreline and into the distance is the final resting place of the Chinese Princess and her ivory chest. Best not go looking for it though ... you could be the ghostly canine's next victim. (© David Scanlan)

Launceston Priory, Launceston

The town of Launceston – Laanstefan in the native Cornish – translates as the 'church site of St Stephen'. When the Normans invaded Cornwall in 1067 they constructed a motte-and-bailey castle at a place called Dunheved, the Saxon name at the time for what was to become the town known today as Launceston. There was a priory of Augustinian canons located here, the remains of which can be seen behind the church of St Thomas.

In 1155 the canons had a new priory built for them following the destruction of their church tower in a feud between two Norman factions. The priory and its brethren of Augustinian canons flourished for over four centuries until Henry VIII and the Dissolution of the Monasteries loomed on the horizon. Henry's changes to the religious communities of the time affected many abbeys, priories, friaries and monasteries. All in all 825 religious establishments were closed down.

Monks, nuns, priests and vicars are people who devote their lives to the worship of God and the sacred places, their churches, chapels, abbeys and the like, were an essential and loved element of their lives devoted to their faith, so it comes as no surprise to find out that many religious buildings and establishments have the ghosts of these long-forgotten devotees. Some people claim to have witnessed the spectre of a black-clad Augustinian monk still moving amongst Launceston Priory ruins.

Only a few rocks remain of the once grand Launceston Priory but that doesn't stop the resident ghost haunting it. (© David Scanlan)

Lost Gardens of Heligan,
St Austell

The Lost Gardens of Heligan truly are a success story and a glowing example of what can be achieved when people put their hearts and minds to a task in hand, for until the 1990s the exquisite landscaped gardens here were lost to the ravages of time and the overgrowth of nature for over seventy-five years.

The estate boasts an impressive ownership of land covering some 300 acres, 200 of which are open to members of the public. The history of the site goes as far back as the thirteenth century when the first manor on the land was built. Obviously this ancient house no longer stands as the manor was rebuilt firstly in 1603 and then again in 1692. The Tremayne family continually improved the lands surrounding their manor and from 1766 onwards there was a variety of rides constructed around the grounds and various exotic gardens planted such as the Japanese Garden, Melon Yard, Flower Garden and Pineapple Pit to name a few.

The years raced by but eventually time caught up with the Lost Gardens of Heligan and things started to slip away. I spoke to marketing assistant James Stephens who told me that 'The coming of the First World War (1914–18) took many of the experienced gardeners needed to maintain the grounds away from their beloved employment and to the battlefield.' Many of these never returned as they were killed in action. The Tremayne family finances also started to decline somewhat and the last Tremayne to live in the property on the grounds decided to vacate the house because of his fear that the house was haunted. 'It was just one of those things where many events that came along together, put pressure on the family and things started to fall apart.' Is the Tremayne house still haunted to this day I asked? I was quite surprised by James' response. 'It never was as far as I know,' replied James. 'Squire Tremayne just believed it was and because of that he didn't want to stay in it.'

Perhaps the house was haunted. Perhaps it wasn't. But the stories abounding around the estate of people seeing a Grey Lady came in so frequently that the area in which this supernatural visitor was most often seen eventually became known as Grey Lady's Walk. People commented on seeing the ghost walking away from the house and one elderly resident claims that she even followed the ghost on one occasion and watched her simply disappear into the trees. The ghost has evoked so much interest over the years that eventually a modern-day sculpture was erected and now stands in the Woodland Walk and the accompanying plaque tells her story.

Over the years many a visitor has enquired as to whether the gardens are haunted or not. Many claim they feel they have walked with spirits in the grounds. One couple visiting the dark house in the Melon Garden were astounded to watch the lids on a series of forcing pots systematically lift one by one before hearing a loud sigh from

The Grey Lady sculpture in the woodlands that commemorate the sightings of this phantom. Who she is and why she remains no one knows! (© Lost Gardens of Heligan)

an unseen presence. Could this have been the ghost of one of the former gardeners returning to check on his crops? Maybe the Grey Lady has an interest in watching the plants flourish? Or just maybe ... this might be a ghost whose identity we have yet to discover.

There's no doubt that strange and unusual events have occurred in the Lost Gardens of Heligan. So many independent and unrelated witnesses cannot be wrong ... can they?

Lyonesse, Land's End

The land of Lyonesse, an area said to lie between Land's End and the Scilly Isles, is a place wrapped up tightly in mystery and myth. The earliest reference to Lyonesse, as researched by Dr Patrick Roper, is from a thirteenth-century poet named Beroul who was made famous by writing the legends of Tristan into the Norman language, who refers to a place known as Loenois. It is quite common in historical record to find different spellings for place names as time progresses.

This mythical land is said to have had over 140 churches and been a busy, thriving town but for some reason it completely vanished into the sea. Legends abound stating that Lyonesse was sunk by the ghost of Merlin, from Arthurian legend, where as other sources lead us to believe that the cause of the land's disappearance was simply down to erosion from the sea and wind. Other texts state the lands were consumed in a catastrophe and they were flooded, possibly following some distant tsunami. What really did happen to Lyonesse? We shall never know for certain. Fishermen working the sea around the area off Land's End, the Scilly Isles and beyond claim to hear, from time to time, the muffled sounds of church bells ringing out from below the ocean waves, possibly from some of the 140 churches that sank into the sea many hundreds of years ago.

The view from Land's End looking towards the Longships Lighthouse and towards the alleged resting place of Lyonesse. (© David Scanlan)

Mawnan Smith Church, Mawnan Smith

When one sits and ponders the inexplicable mysteries of cryptozoological wonders then one instantly thinks of creatures such as the Loch Ness Monster, the Abominable Snowman, the Sasquatch of the Americas or terrifying hell hounds with their flame red eyes. However, there is one Cornish mystery to this day that remains puzzling, but albeit forgotten: the Owlman of Mawnan Smith.

In April 1976 two young sisters who were holidaying in the area reported witnessing a large owl-like creature seen hovering about the church tower. The sisters were that distressed at their sighting that their father cut short the family holiday and left the area. There was a further sighting, again by two girls, who were camping in the area in July 1976, only three months after the original sighting of the Owlman. The teenagers described the horror they beheld as 'a big owl with pointed ears, as big as a man, with glowing eyes and black, pincer-like claws'. Surely, any unnatural creature of that stature or description would be enough to send shivers down the spines of the most hardened paranormal investigators and researchers.

There were further reported occurrences of the Owlman phenomena in 1978, 1979, 1989 and 1995 but the mystery maybe nothing more than a hoax. It is worth noting that the first two reports of the Owlman being sighted were reported to Tony 'Doc' Shiels, who went public with the stories. Shiels is a magician, writer, psychic entertainer and well-known hoaxer who also claims to have photographed the Loch Ness Monster. Could it be that this mystery remains to this day simply because of the intentions of a hoaxer? Or could there actually be something to the mystery of the Owlman of Mawnan Smith and all Shiels was doing was reporting the facts?

St Mawnan and St Stephen's Church, where the Owlman has been witnessed. (© Phillip White/Mawnan Church/ CC BY-SA 2.0)

Molesworth Arms Hotel, Wadebridge

The small market town of Wadebridge was formerly known as Wade until a bridge was built across the River Camel in 1468. There were two chapels. On one side of the river was a chapel in which people who were going to cross the treacherous river would pray at in the hope of safe deliverance. If safely across they would the pray at the other chapel to give thanks for the safe crossing.

The Molesworth Arms, a sixteenth-century coaching inn sporting past names such as the Fox, The Fountain and the King's Arms, has one ghost that is known as a cyclical ghost. Cyclical ghosts are those entities that return on a regular basis – the same date, doing the same thing, year after year. The ghost here is said to appear every New Year's Eve and is that of a headless horseman pulling a carriage driven

Old Bridge at Wadebridge, where the spectral wraiths of a coach and horses complete with driver and passengers has been witnessed. (© David Scanlan)

by four horses. The coach enters the courtyard of the Molesworth Arms Hotel, comes to a stop and three passengers alight the carriage before all vanish into thin air.

Being a cyclical ghost and therefore one that can be expected at a particular time, I contacted the pub and spoke to Dave Mortlock, the current owner. He told me, 'My chef here is Sean Cassidy and his dad (Nigel) ran the pub for twemty years up to about ten years ago. He has good knowledge of the pub and the ghost and has witnessed this.' When I enquired further if the ghost had been spotted this New Year's Eve (2019/2020) Mr Mortlock said, 'This year there was an occurrence although I only witnessed this through the window by way of a shadow and the noise. It was at about 1.30am as I was closing down. I ran to the front window and saw what looked like the back of a carriage which turned left up Whiterock Road.' It seems after many years the phantom coach, its horses, its headless horseman and maybe its passengers arc still making their ethereal journey.

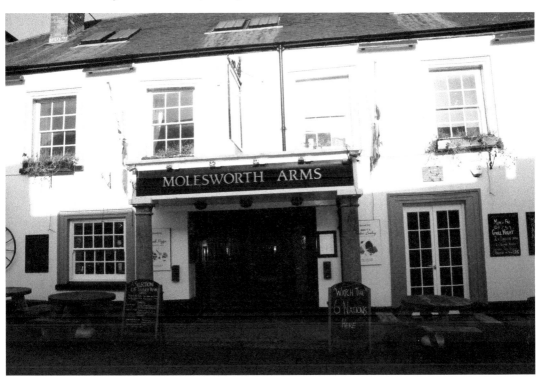

The Molesworth Arms courtyard entrance. The final destination for the phantoms of a headless horseman, his horses, carriage and three passengers that are seen to arrive every New Year's Eve. (© David Scanlan)

Museum of Witchcraft, Boscastle

This rather unique museum, containing over 4,000 occult objects, boasts proudly on its website 'The Museum of Witchcraft in Boscastle, Cornwall, houses the world's largest collection of witchcraft related artefacts and regalia. The museum has been located in Boscastle for fifty years and is amongst Cornwall's most popular museums.' Despite it being somewhat of a place of pilgrimage for many a follower of 'the craft', the museum has always been a place of controversy.

A few years back I remember watching a TV series in which the museum featured. During the filming a local resident came out and spoke to the camera crew to ensure her house was not in view on the recording and to voice her objections to the museum and witchcraft in general. She didn't want her house being seen on the show as she was a Christian and didn't want to be associated with the place in any way! That goes to show to some extent how people object and feel about witchcraft. But what is witchcraft and why so many objections? Christians and many other mainstream religions say that it is the religion of the Devil and its followers are worshipping Satan. Speak to the followers and they counter-claim this statement by saying that witchcraft is an ancient belief system associated with good acts such as white magic and healing the sick and injured. Despite the disdain from many, witchcraft and paganism in general has witnessed an increase in its followers in recent years.

With such a rich tapestry of history and myth, witchcraft has inevitably come to surround itself with many objects that some may consider, well, unorthodox shall we say. A poppet (similar to a voodoo doll) with a dagger imbedded in its stomach which was a spell meant to resolve an unwanted pregnancy, ceremonial daggers, a sickle inscribed with black magic symbols, incense burners, various mirrors and pans used in scrying (the process of divination by gazing into an object such as a crystal ball), jewellery made from animal bones and of course a collection of effigies and statues including one of the horned god commonly associated with witchcraft are all on display at the museum. Now, it's well worth taking the time to clear up some misunderstandings concerning this much-feared god of witchcraft. To those of a Christian faith his appearance is that of the Devil, a part-man part-beast abomination that enjoys doing evil deeds and punishing those around him. To witchcraft practitioners he is the opposite. He is the father god; a god of virility, wilderness and hunting. It is also said he collects the dead and takes them to wait in the Summerland before being reincarnated. Like one man's rubbish is another man's gold, here we have one man's god is another man's devil!

The museum and its collection have attracted the enquiries of many a paranormal investigator asking if the museum itself is haunted. Perhaps the building is not haunted in itself but what about the possibility of their being a haunted object in the museum?

The Museum of Witchcraft at Boscastle. (© David Scanlan)

The horned god Baphomet at the Witchcraft Museum. (© Clare Lewis)

I contacted the museum to find out if they had had any unusual or supernatural encounters and it seems they have. Museum employee Hannah Fox told me, 'Although we do not have a specific object that is haunted, odd noises, objects moving occasionally, and movement in the shadows is all part of life here.' Hannah went on to tell me that in the past few years they have indeed had the occasional paranormal investigation or two.

I managed to track down a lady by the name of Clare Lewis who owns the shop Luna Orbis (lunaorbis.co.uk) and who has conducted a series of investigations at the museum. She told me that during their vigils there they have experienced a range of phenomena including witnessing shadows, hearing whispering noises, hearing the sound of the current owner's deceased pet cat and seeing a crystal ball mysteriously glow on its own accord when the museum's founder, Cecil Williamson, was mentioned during one night-time investigation. Clare also told me how one of her investigators claimed to have been chased up the stairs by the spirit of a mandrake. (A mandrake is a hallucinogenic plant used in witchcraft.) History records show that people trained dogs to dig the roots up, as legend tells us that when a mandrake root is pulled from the ground it emits a loud scream that can kill. Clare told me that 'in witchcraft mandrakes were used as poppets to assist with a witch's bidding/to help control the will of another. They ultimately took on a life of their own as an effect of this.' I asked Clare if she's ever brought a mandrake to life herself and she said 'No. But I'd be willing to give it a go.'

As a rather spooky side note to end this story on, when I was writing this article and actually speaking to the museum curator on the phone, one of my daughter's electronic toys suddenly sprung to life on its own (new toy with new batteries, so no technical faults) and my mobile phone suddenly crashed and wouldn't turn on again even though the phone is relatively new and was fully charged. The toy continued to work on its own until I asked out aloud for it to stop. It stopped suddenly. Coincidence? Perhaps the spirits that haunt the Museum of Witchcraft paid me a fleeting visit?

A selection of Poppets used in combination with magik to inflict pain and suffering upon an intended victim. (© Clare Lewis)

Pendeen Fogou, Lower Boscaswell

I remember many years ago when I was studying archaeology at A Level we covered the topic of Cornish fogous and they have fascinated me ever since.

Historical and archaeological evidence leads us to believe that fogous are Iron Age constructions made from buried stones topped with stone slabs that form a small underground chamber but their exact use remains a complete mystery. Suggestions for fogous being used for food storage, refuge and even religious ceremonies have long been considered but the jury is out on this one and I don't think we will ever know for certain what their exact purpose was or why they were constructed.

The Pendeen Fogou has a ghost that sticks to a time frame, referred to as a cyclical ghost because it follows the same time span cycle for many successive generations, and the spirit of a woman dressed in white, seen carrying a red rose between her teeth, has been witnessed walking into the fogou. If you would like to see this ghost then you need to be at the fogou on 21 or 22 December, but be warned. Some say that seeing this ghost brings nothing but misfortune upon those who witness her!

Pendennis Castle, Falmouth

Originally constructed under the orders of Henry VIII from 1540 to 1542, the aim of Pendennis Castle was to protect the Carrick Roads Waterway at the mouth of the River Fal from the threat of invasion by the French and the Holy Roman Empire, one in a series of fortifications ordered by the King to protect England from attack. The castle has seen its fair share of history, from Tudor times through to the English Civil War, in which approximately 100 soldiers died as a result of the naval blockade of the sea routes that would bring in supplies to the Royalist stronghold, to the onslaught of cannon attack from Parliamentarian colonels Fortescue and Hammond, and to the Second World War in which the castle became an artillery battery.

 With such a rich tapestry of history it makes sense that a ghost or two walks within the confines of this historic fortification; in fact, there are at least three ghosts and possibly even more. It is hard to determine exactly how many ghosts are still contained within the walls of this fort as the spirits here are rarely seen but are often heard. The footsteps of soldiers are heard making their way up the stone staircases, the frightening and blood-curdling scream of a kitchen maid who allegedly fell to her death has been heard by both visitors to the castle and the staff that work here, the laughter of children has been reported and the ghosts of a former cook and a lieutenant governor have also been spotted throughout the castle's history. In my opinion, in my capacity as an experienced and well-established ghost hunter, this is an ideal venue for a paranormal investigation. Ghosts are rarely seen, even more so during a ghost hunt, but the sounds of those who have gone long before appear to linger on and provide, possibly, the best evidence for the existence of the paranormal.

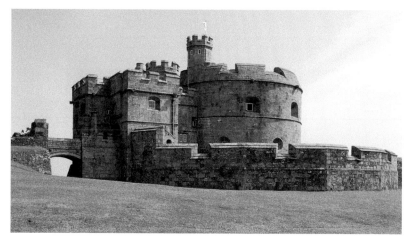

The blood-curdling scream of one of the ghosts of Pendennis Castle must be one of the most shocking occurrences to experience. (© Nilfanion/ Pendennis Castle Keep/ CC BY-SA 3.0)

Pengersick Castle, Praa Sands

Pengersick Castle is a well-known haunted place and many paranormal investigators and supernatural enthusiasts have descended upon it in recent years in the hope of uncovering and explaining many of the legends and ghost stories that surround this historical place.

The original castle on the site was constructed around the twelfth century and the first family to inhabit the property took their names from the area in which they settled in and became known as the Pengersicks. The castle went through various times, good and bad, and all that is left of Pengersick Castle now is the fortified Tudor Manor House which was fortified shortly after the Portuguese ship *The St Anthony* was wrecked off the nearby coast on 19 January 1527 with an estimated cargo value of £18,880. (It's claimed that the then owner of the castle, John Milliton of Pengersick, was involved in the plundering of the wreck but no proof was ever discovered.) The oldest part of the Manor House dates to around 1500.

The castle is rumoured to be haunted by a plethora of ghosts, including the ghost of a monk who was murdered by a former owner of the castle, a woman who has been witnessed looking out through an upstairs window before making her way towards the bed, laying down and then writhing around in pain. There is also the story of a baby who was murdered in this room shortly after being born, so could the pangs of labour still be being shown, albeit in spectral form? This woman is consoled in her etheric agony by the apparition of a woman, maybe a nurse or friend, who stands beside her bed in a gesture of comfort, or perhaps getting ready to do away with the newly born child. There are also the ghosts of a girl who is said to be thirteen years old, a four-year-old boy, the ghost of a man who was murdered by the fireplace in the main bed chamber, the spectre of a black cat and also a phantom hell hound with fiery red eyes.

The ghosts that are said to roam Pengersick Castle are truly ghosts of traditional legend and folklore but are all the stories accurate?

For me personally I find many of the stories a little too hard to believe, for instance the story concerning the hell hound. This area was, as were many other areas of Cornwall, rife with smuggling and I have seen in numerous areas, in both Cornwall and beyond, stories that were created by smugglers in order to breed fear into the locals so that they wouldn't be tempted to enquire into the smugglers' night-time activities. What better way to keep the superstitious locals away from your illegal shenanigans than a good, terrifying ghost story? There are also no records of a monk being killed on the site. There are records of an assault being perpetrated against a monk, here so I would have thought if people at the time saw fit to acknowledge and record an assault they would surely have not missed the murder of a man of God ... would they?

The historical, atmospheric and haunted Pengersick Castle. (© David Scanlan)

There are, without doubt, ghosts at Pengersick Castle. The eye-witness testimonies, sounds of unexplained bangs, feelings of being watched and even at least two accounts of people being sexually groped all pertain to the fact that something other-worldly is occurring here, but sorting out the facts from the fantasies could take some time yet.

Penhallow Manor, Altarnun

This picturesque Grade II listed manor house, formerly the Vicarage (built in 1842) for the adjacent fifteenth-century Church of St Nonna, is steeped in paranormal history and is famous worldwide as the church and vicarage that inspired author Daphne Du Maurier (1907–89), who visited here in 1930 when writing her classic tale of murder centred around the nefarious activities of a group of Cornish wreckers (local folk who lured ships to their doom by waving lanterns on the rocky shoreline which led ship captains to believe it was safe to harbour but ultimately steering their vessels to be destroyed on the jagged and merciless rocks). The wreckers would then pillage the cargo and the bodies that washed up on the shore, and if you were unlucky enough to survive drowning in the crashing waves then the wreckers would make sure you wouldn't survive long enough to tell your tale of woe.

Now a private residence, the manor was featured in the 1997 UK TV series *Ghost Hunters*, which covered the haunting of this property in some detail. Previous owners of Penhallow Manor had decided to call in psychic medium Harry Cleverley, then a resident in the village, after they had experienced the feeling of a presence in the property and after hearing footsteps on the stairs and overhead when no one was present. Using his mediumistic ability Mr Cleverley gained the impressions of a vicar, dressed in a frock coat, who paced up and down as if reflecting on a perplexing problem. He also related a tale about one of housekeepers who was having an affair with the Revd Robert Henry Tripp, a one-time rector at the church and resident of Penhallow Manor.

The *Ghost Hunters* TV crew decided to recruit the services of another medium, Shirley Wallis. Ms Wallis stated she had no knowledge of the haunting of Penhallow

Penhallow Manor in Altarnun. The scene of an illicit love affair and the home to three spectral inhabitants. (© David Scanlan)

Manor and had never met nor knew of the psychic impressions of Mr Cleverley. In fact she even stated she would be willing to undertake a lie detector test to confirm these statements. After walking around the manor and getting a feeling for the place she recounted the psychic impression of a reverend haunting the property; he paced up and down with his hands behind his back. She commented in one of the upstairs rooms that the room seemed to be this reverend's 'bolthole'; a place where he relaxed and worked in sight of St Nonna's Church, which could be seen through the window. Shirley also stated that there were 'undertones' to the presence of the vicar and that she was inclined to believe he was having an affair with a servant at the house whose spirit she encountered in the manor's kitchen. These impressions from Harry Cleverley and Shirley Wallis, without knowledge of each other and therefore recounting completely independent claims that match, add an interesting amount of weight behind the arguments for these two spirits to be present in Penhallow Manor.

The ghost of a woman believed to be Mary Hurley has been seen at Penhallow Manor standing at the backdoor and in the windows, and it's been suggested that this was the woman who was having the affair with the Revd Tripp. Mary apparently drowned in the nearby river after falling from the small bridge in the village. Did she commit suicide because of the affair, was it an accident or is this element of the story a complete fallacy? During the writing of *Paranormal Cornwall* my good friends and fellow paranormal investigators with the Hampshire Ghost Club Richard Abbott amd Lesley Johnson conducted some in-depth research into Mary Hurley. They were able to ascertain that she was indeed a servant based at Penhallow Manor as recorded in the 1851 and 1861 census. Her age at the last census was seventy-seven, some eighteen years the senior of Revd Tripp, and her death occurred on 11 January 1863 with the burial record being signed by Tripp himself! Her death is somewhat, sadly, still a bit of a mystery as her death certificate states she passed away due to old age. However, this cause of death was listed as 'not certified', but a medical doctor would surely be able to deduce drowning as a cause of death in a victim. Historical research via the coroner's reports has indicated that no one named Mary Hurley died from drowning in Altarnun. Either way her death remains a little odd, but it seems she wasn't a victim of drowning.

Over the years the legends of this affair between Hurley and Tripp have escalated and some have even said that Hurley shares a grave with Tripp and his wife's grave is nowhere to be found. Well, at last I am able to confirm this is completely false. Tripp and his wife do share a grave together at St Nonna's and his daughter, Elizabeth, and Mary Hurley, share a grave next to the reverend and his wife. To be honest this fact tends to throw the whole affair between Tripp and Hurley into nothing more than speculation.

A further ghost, perhaps the reverend's wife, also haunts Penhallow Manor as the wraith of a woman dressed in grey Quaker clothing has also been reported at the house.

A further spectral encounter was had at the gates of St Nonna's Church, also by Mr Cleverley, many years before his interest in the paranormal and mediumship started. Walking past the church gates at midnight he witnessed a 'floating entity' make its way down the cemetery path which then proceeded to pass through the metal gateway entrance of the church before vanishing before his very eyes. The gates were firmly closed and when he recounted his experience to others in the village he discovered he was not alone in witnessing this apparition which is commonly believed to be that of Mary Hurley.

The gravestone of Elizabeth Tripp, the reverend's daughter, and Mary Hurley. (© David Scanlan)

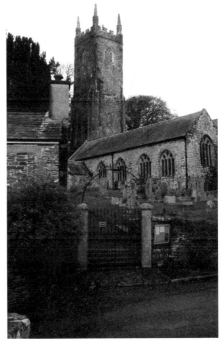

Above: The graves of Robert and Elizabeth Tripp (left) and Elizabeth Tripp (his daughter) and Mary Hurley lay next to each other in the graveyard of St Nonna's Church in Altarnun. Revd Tripp's simple grave marker states 'Robert Henry Tripp, M.A. Oxon.; for 37 years Vicar of this parish, who fell asleep March 13th, 1880, aged 72 years.' (© David Scanlan)

Right: St Nonna's Church showing the wrought-iron gates at which many people claim to have witnessed an apparition, possibly of Mary Hurley, passing through. (© Summer Scanlan)

CHAPTER THIRTY-FOUR

Perranzabuloe Church, Perranzabuloe

The particular haunting surrounding this church appears to be a one-off incident. In Peter Underwood's 1998 edition of *Ghosts of Cornwall* he relates a tale that even the most avid believer in paranormal phenomena would probably raise a quirky smirk at.

He states that an old woman discovered a pair of false teeth sticking out of the ground in the church's graveyard. For some strange reason she decided to gather up the false set of gnashers in the hope that she would find some use for them at a later date.

That night however she was visited by the ghost of whose teeth she had stolen from the graveyard. The spectre loitering at her cottage window shouted 'Give me back my teeth, give me back my teeth'. The old lady is said to have gathered up the teeth, flung them into the garden and when she did so the ghostly voice and presence fell silent instantly. Come the following morning no evidence of a mortal presence outside the cottage was discovered and the teeth had vanished!

What exactly a ghost would need their false teeth for baffles me. Then again. If someone stole something of yours, even if you didn't need it, you would still want it back wouldn't you?

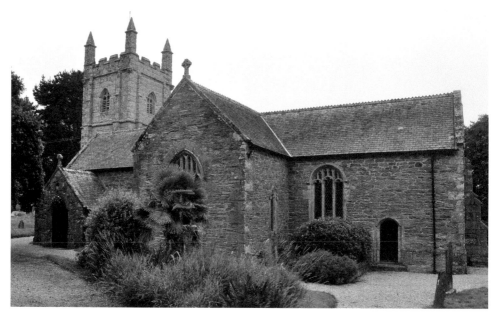

If you spot something unusual on the ground whilst visiting Perranzabuloe church it's probably best you leave it there in case you get a spectral visitor in the dead of the night. (© Nilfanion/ Perranzabuloe church 2/CC BY-SA 3.0)

Polar Bear Fish Bar (former), Bridgwater

The usual spectral stomping grounds for ghosts include graveyards, churches, stately homes, battlefields and of course castles, but there are also many places that claim to be haunted that you wouldn't normally expect. This is one such haunting.

Sitting on St Johns Road in Bridgwater is the former Polar Bear Fish Bar. The shop rose to some fame in 2009 when it featured in various newspapers, such as the *Bridgwater Mercury*, after its owners, Carla Richards and Amanda Hunter, went public over the unusual activity they had been experiencing at the shop.

Since taking over the premises in July 2008 the owners and various other people have been privy to a host of supernatural occurrences including pots and pans moving by their own volition, sudden temperature drops, fleeting glimpses from the corner of the eye, footsteps and doors opening and closing on their own. One of the strangest incidences to date, for me at least, was when employee Sam Hill was busy working away and happened to be whistling to herself. Sam claims that an unexplained whistling sound copied her and whistled back. Who or what haunts the fish bar remains to be confirmed for certain. I wonder if the new owners of the shop have experienced any odd occurrences since taking over.

Poldark Mine, Helston

Claiming to be one of the deepest mines in Britain, Poldark Mine is certainly a place in which you can imagine a ghost or two lurking around the corner.

The history of tin mining on the site goes back to the deepest ages of our ancestors when in prehistoric times alluvial tin was mined here. Historical research and evidence shows that the mine was a successful business from 1720 to 1780 and around its peak is said to have employed hundreds of men and boys who would risk their lives in order to extract the tin from the tough Cornish rock. Getting the tin out of the rock was a dangerous procedure which involved packing gunpowder tightly into a hole in the rock, made by the miners, lighting a small fuse and then literally running for your life before the gunpowder exploded, blowing apart tons of rock and invariably, you can suspect, the occasional miner who didn't run quick enough!

Following its success in the eighteenth century the mine was eventually abandoned and forgotten. In 1972 retired Royal Marine Peter Young decided to buy the site to establish a steam engine museum on the land. The compressors that were used at the site to run the steam engines were so noisy that eventually Peter decided to excavate part of the hillside and place the compressors in the land hoping that the hill would act as a natural soundproof barrier. Digging into the hillside you can imagine Mr Young's surprise when he accidentally stumbled across the remains of what we now know as Poldark Mine.

Poldark Mine is a relatively new name for the site and some readers of *Paranormal Cornwall* of a certain age will recall the popular BBC TV series *Poldark*, which ran between 1975 and 1977 and which was based on the novel by Winston Graham. Various scenes used in the show were actually filmed at the mine and therefore the venue changed its name to reflect the show's popularity. The mine was formerly known as Wheal Roots Mine.

Working deep underground, using explosives and a complete lack of health and safety is what probably led to the ghosts haunting this old place, as accidents resulting in fatalities would have been commonplace. People who claim to have experienced the supernatural here have said that they have heard strange and unaccounted for noises emanating from deep within the mine itself. Other say they have actually seen the ghost of Poldark Mine and have reported a spectral figure dressed completely in brown lurking around the deep, dark and atmospheric depths of the mine. Could this ghost be all that remains of a long-dead miner who, it seems, is not quite ready to give up his job?

Porthgwidden Beach, St Ives

If you happen to be taking a stroll along Porthgwidden Beach do not be alarmed if you should happen across a phantom white horse. Local legend tells us of a man who owned a stunning white horse and he would ride this steed down to Porthgwidden Beach each evening, leaving his animal on the sand whilst he took a swim.

Such was this a regular occurrence that when the locals noticed the horse on the beach much longer than normal they went to investigate and found the owner of the horse had drowned. The horse was loyal to his owner and resisted attempts to lure him away, but eventually he was encouraged away to carry on his life without his beloved master. Following the steed's death people claimed to have seen the white horse making its way down Island Road and heading towards the beach. There are even accounts of people witnessing the ghostly horse returning from the beach and apparently being ridden by the ghost of its former master. Could it be that the bond man and animal shared in life was so intense that not even death could separate them from each other?

Prideaux Place, Padstow

This glorious Elizabethan mansion, completed in 1592, has been the seat of the Prideaux family for over 425 years. The family have a rich ancestry and their descendants include historical greats such as William the Conqueror and King Edward I. During the English Civil War the family supported the Parliamentarian cause and narrowly avoided having their home and lands confiscated due to a marriage between a daughter of the Prideaux line to William Morice of Werrington (1628–90) who was the Secretary of State to the newly restored King Charles II. This fateful marriage meant a royal pardon from the king, so the family, their home and their lands were all saved from ruin.

With eighty-one rooms in Prideaux Place you might be hard pushed to bump into a ghost, but as the mansion has a total of four ghosts, maybe more, your chances are increased somewhat. There is the apparition of a playful boy who has been witnessed running around the kitchen, various ladies sporting differing attire that have been seen on both the staircase and in the morning room but the most ominous room at the mansion is the Grenville Room. People here say the room has an oppressive feeling and their presence in the room is felt as being distinctly unwelcomed. In this room people have also heard an unseen dog growling and have also bore witness to glowing red eyes – maybe the growling and the red eyes are connected to an infamous hell hound but we are unable to confirm this as the growling and the red eyes are always seen separately and never together. Finally, what historical home would be complete without the ghost of a Green Lady. This apparition is believed to be of a woman who was either murdered by being pushed from a window or who innocently fell. Even if you don't get the chance to attend a paranormal investigation at Prideaux Place the mansion is most certainly worth a visit, and when you consider that more people report witnessing ghosts in daylight than at night-time, then perhaps your odds of encountering the spectres of this home are good.

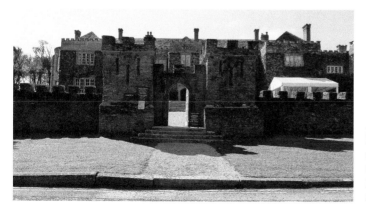

At Prideaux Place you will be spoilt for choice on the selection of ghosts on offer. (© Rob Farrow/Prideaux Place from the east/ CC BY-SA 2.0)

Punch Bowl Inn, Lanreath

In the village of Lanreath you can find the Punch Bowl Inn, a former coaching inn whose licence dates back to 1620. Sadly, at the time of writing this book, you won't be able to pop in for a swift drink for in May 2012 the pub closed its doors for the last time. Occasionally in the role of investigating the paranormal you come across many a story or legend connected to a haunting that just seems plain bizarre and the ghost of the Punch Bowl Inn is one such story.

Many years back the local rector of the town was wining and dining his curate and all was going well until the alcohol dried up. The rector went to his cellar to fetch more alcohol but he somehow managed to slip and fall down the cellar's steps to his death. It wasn't long before rumours started and people were gossiping that the rector's death had not been an accident and he was, in fact, pushed by the curate who was having an affair with the rector's wife – pure speculation but it could be the reason as to why the rector's ghost returned.

The following day the ghost of the rector was said to have returned to the village, not in his former personal appearance as one would think but as that of a spectral black cockerel that attacked anyone who should be unlucky enough to cross his path. The Black Cockerel eventually found its way into the Punch Bowl Inn where a kitchen maid managed to trap the bird in an oven. The oven was subsequently bricked up to stop the malicious animal escaping and causing further harm to the villagers of Lanreath. As a ghost doesn't have a body to sustain with food or drink, nor does it require oxygen to breathe, one must wonder if this spectral cockerel is still bricked up in walls to this day!

If dining at the Punch Bowl Inn at Lanreath it's probably best not to order the chicken. You might just be tucking into the spectral cockerel that's been sighted here. (© Kate Jewell/The Punch Bowl Inn, Lanreath/ CC BY-SA 2.0)

Queens Square, Penzance

Where would you expect to see a ghost? A castle, a fort, a stately home or a creepy graveyard? You wouldn't be far wrong but from time to time we find ghosts in some of the most unexpected locations.

In Queens Square in Penzance lies the local Co-operative store. This store has its own ghost as well as groceries, although it's not for sale. Staff here have come to call the ghost 'George', although no one knows the spirit's true name – or gender for that matter – but it has made its presence known.

In 2003 CCTV footage apparently showed a four pack of lagers flying off a shelf and landing around 2 feet away, so it simply didn't fall; there must have been some kind of unexplainable force behind the item that caused it to move such a distance. This isn't the only case of the inexplicable occurring at the store, and staff here have reported other items apparently moving of their own accord.

A medium eventually visited the Co-operative and related that the presence haunting the store wasn't nasty or malicious but was somewhat mischievous. The medium also told staff to expect electrical problems in the shop – a common facet of some hauntings. Sure enough the store did have electrical problems including a power cut which could not be explained and tills going mad for no reason whatsoever.

CHAPTER FORTY-ONE

Roche Rock, Roche

If you read back through the stories of this book to Dozmary Pool you will recount the story of the infamous Jan Tregeagle which might explain the phantom that has been seen at this somewhat spooky and eerie-looking outcrop.

Roche Rock is a 20-metre-high (65-foot) rocky structure that is composed of various geological entities including granite, quartz and black tourmaline crystals. Could it be these geological components contribute to the haunting here? Possibly. But legends persist here of it being a gathering place of witches and demons before the coming of Christianity. Sitting precariously atop of the rock is the Chapel of St Michael, built deliberately many generations ago in order for the priests of Christianity to enforce their dominance upon the suspected witches and demons who used to use the rock – Christianity was letting the native religions know they were no longer welcome here!

So, with stories of witches, demons and men of faith residing upon the rock, could it be one of these culprits whose ghost has been witnessed here? People claim to have seen a black, shadowy apparition moving about the rock and appearing in the now derelict windows of St Michael's Chapel. Theories have abounded over the years stating the ghost is that of a monk or even that of a leper who took to living in the chapel to avoid village folk.

The chapel at Roche Rock. (© David Scanlan)

Roughtor, Bodmin Moor

Also known as Rough Tor, this rocky outcrop rising from the landscape of Bodmin Moor is notorious in Cornwall as being the site of the county's most famous and tragic murder.

On Sunday 14 April 1844 two young lovers, Matthew Weeks (sometimes spelled Weekes), a handicapped farmhand, and his girlfriend Charlotte Dymond, a servant from Penhale Farm, went to spend some time together on the moor. History doesn't know for certain what happened between the two lovers, but during their time up there Matthew is said to have drawn a razor he had concealed about himself and slashed Charlotte's throat. Her body was found in nearby Roughtor Ford a week later.

Knowing that Matthew was Charlotte's boyfriend, a search for him ensued and he was eventually discovered in Plymouth and arrested. He was tried at Shire Hall in Bodmin where he was found guilty and sentenced to death. Following the passing of the guilty verdict Matthew was publicly hanged in Bodmin on 12 August 1844. In recent years doubt has been raised as to the guilt of Matthew Weeks.

Since Charlotte's horrid murder over 160 years ago, people claim to have seen the ghost of her, especially around the anniversary of her murder, wandering the tor where her life was so abruptly ended. She is recognised as wearing a gown, red shawl and silk bonnet.

Roughtor, where Charlotte Dymond was brutally murdered. (© Kevin Walsh/Roughtor Bodmin Moor/CC BY-SA 2.0)

St Bartholomew's Church, Warleggan

This Grade II* listed church dating back to the thirteenth century is not the haunt of some age-old ghoul, spectre, spook or spirit but the spiritual remnants of a much more modern ghost. In 1931 the Revd Frederick William Densham (1870–1953) took over the parish as the incumbent vicar. Shortly after his arrival it became apparent that his behaviour was alienating his flock. He had a dislike of organ music, fundraising drives, cancelled the Sunday school, purchased a litter of puppies (which in a sheep farming community was a definite no-no), suggested selling the church organ in favour of a piano and even once painted the church in outlandish colours which greatly upset the parishioners.

Due to his eccentric nature it wasn't long before he found his church lacking a major factor: his congregation. People simply stopped coming to his church. Densham

The rear elevation of St Bartholomew's Church at Warleggan. This was the parish church of the eccentric and lonely Revd Densham for some twenty-two years. (© David Scanlan)

noted the lack of parishioners attending his services in his official church records and even started writing the names of past church vicars on small cards that he would place in the pews so he would have someone to preach to!

One day in 1953 the reverend laid out some apples with a list of sick parishioners to whom they should be distributed and started to ascend the stairs to his bed. It appears from this act that Densham could possibly have known his end was near. He never made it to his bed; he collapsed on the stairs and died alone at the age of eighty-three. It was two days before his body was found and even in death his parishioners could not forgive his eccentric ways as his request for his ashes to be scattered in the churchyard were ignored. The story of the Revd Densham was made into a feature film in 2009 called *A Congregation of Ghosts* starring actor Edward Woodward (1930–2009) in the lead role. It was Woodward's final movie before his own death.

Perhaps it is the lonely, misunderstood life that Densham led which has now bound his spirit to wander the pathway leading to the vicarage, of which there have been many witnesses. It is somewhat saddening to think that a man who craved human company so dearly should be condemned to wander the realms of his old church in isolation.

The interior of St Bartholomew's Church. It was in the first six lines of pews that the Revd Densham would lay out memorial cards for the past rectors, simply so he had someone to preach to. (© David Scanlan)

St Ives Beach and Bay, St Ives

With a rugged and harsh coastline and a history of shipping, smuggling and piracy it's no surprise that the history of Cornwall is littered with many a tale of a shipwrecked vessel.

St Ives Bay, an idyllic sight when viewed either from St Ives itself or from across the water at nearby Hayle Beach, has the ghost of a ship that has been witnessed in the bay. The story goes that an old-style ship has been seen pulling into St Ives Bay signalling for help as it goes. When rescue ships and crews are dispatched to help, the ghostly vessel promptly vanishes from sight, leaving no trace of it ever having been there.

The beach itself is also associated with a haunting – and a tragic one at that. Many years ago a ship was in trouble – maybe even the one previously mentioned – and as the boat steadily crept beneath the waves local fishermen sped to help. One woman, clutching her young baby in her arms, jumped from the stricken vessel but the weather was too strong and tore her baby from her arms, sending the child to a watery grave. Although the mother survived the accident it appears the distress and sadness this event caused had doomed the lady to wander the beach for all eternity. Her ghost has been sighted on stormy nights wandering the beach looking for her child and when people approach the woman she walks towards the sea and vanishes. I do so hope that this ghost is nothing more than a recording in time, an event that has somehow become imprinted into the environment here, as I, for one, would hate to think of someone wandering this earth in such a sad and upsetting fashion. Losing a child in life is every parent's worst nightmare, but to lose your child and then spend eternity looking for your lost babe is something I wouldn't wish on my worst enemy.

On a sunny summer's day St Ives Beach is an idyllic, picturesque scene. The hauntings here, however, make it a place of sadness and loss. (© David Scanlan)

St Kew Inn, Bodmin

This fifteenth-century building appears to have had a long history connected to brewing. It is believed to have been first established by stonemasons for brewing their own beer and taking lodgings whilst constructing the adjacent parish church of St James. The current cellar which underlays the stable bar is thought to be the original brewing house of the masons. During building work here in the 1970s workmen discovered the remains of a grave containing the bones of a teenage girl. Who she is and why she is buried here remain a mystery, but since her tomb was opened the wraith of a bedraggled girl has been seen around the pub, especially when building work is undertaken.

St Kew Inn, where the disturbance of a grave in the property gave rise to its haunting. (© David Scanlan)

St Mary Magdalene Church, Launceston

Do you know what a 'kergrim' is?

A kergrim is the Cornish equivalent of a ghoul and many people think that ghoul is just another word to describe a ghost, but the two are very different indeed. A ghost may walk through walls, stoop at graves, look longingly across the sea for a lover who did not return. They are as varied as they are numerous and each have their own story, but the one thing they share in common is that they are all, with the exception of some crisis apparitions, the wraiths of the dead. A kergrim is different. Firstly, not in all cases do they have to be the spirits of the dead. Secondly, they feast on the flesh of the dead. Thirdly, a kergrim is only active at night so that passers-by do not witness the abominations' cannibalistic feastings – sunlight is said to make the kergrim flee.

So now you know what a kergrim is – a nocturnal, un-dead, cannibalistic creature. Are you ready to meet one? If so then the churchyard of St Mary Magdalene at Launceston is the place to go as local legend states that one of these monsters inhabits the graveyard. If you happen to meet this ghoul then please do let me know … assuming you survive the encounter of course!

The church of St Mary Magdalene in Launceston, where a horrific Kergrim lurks around the graveyard. (© David Scanlan)

St Michael's Mount, Mount's Bay

St Michael's Mount has to be one of Cornwall's most recognisable landmarks and is often compared to its French counterpart, Mont Saint-Michel. Resting on a tidal island, the mount has been inhabited since the Neolithic period. Evidence of occupation from this era comes to us in the form of flint work and a leaf-shaped flint arrowhead.

From the eighth to the eleventh century it is commonly theorised that a monastery may have occupied the site. In 1193 the mount entered into a period of conflict when Sir Henry de la Pomeroy seized the mount. A monastery was built in the twelfth century and passed through to Syon Abbey and then to the Bridgettine Order in 1424. Around 1444 the mount was donated to Kings College, Cambridge, only to be returned to the Syon Abbey order some twenty years later.

From 1473 to 1474 the mount was held by the 13th Earl of Oxford, John de Vere. Perkin Warbeck, pretender to the English throne, occupied the mount in 1497. (Warbeck would later be tricked out of sanctuary he had undertaken at Beaulieu

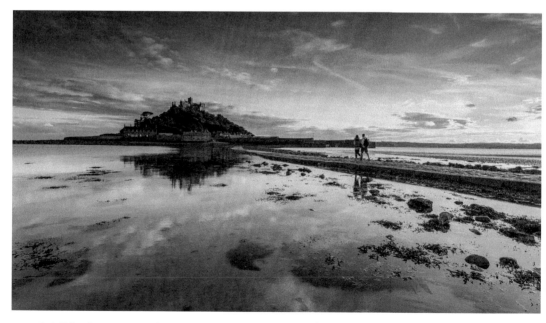

St Michael's Mount at low tide showing the pathway that makes walking to this tidal island an easy task. Just be sure you don't get cut off by the rising tide! (© Fuzzypiggy/St Michael's Mount II5302 x 2982/CC BY-SA 3.0)

Abbey, Hampshire, with a promise of a pardon. He was kept in relative luxury at the king's court following his admission as a pretender. Warbeck was eventually hanged after he attempted to escape.)

In 1659 the mount was sold to a one John St Aubyn, a politician and a colonel in the Parliamentarian army. The descendants of this colonel remain residents of the castle on a 999-year lease which is held in agreement with the National Trust following the mount's partial donation to the trust in 1954. The history of the mount is a rich and varied one and indeed could occupy a whole book to itself quite comfortably, but I digress too long … time to move on to the haunting.

One of the earliest legends I have discovered in connection to the mount is that of Cornish giants! Legends state that the mount was created by the giant Cormoran and also possibly by his wife, Cormelian. The legends surrounding Cormoran are well covered in the book *Jack the Giant Killer*, a fairy-tale of unknown date (although first appearing in printed format in 1711). Cormoran was an aggressive giant and often plagued local communities by stealing their livestock and crops. Eventually a young boy named Jack dug a 22-foot-deep trapping pit, blew a horn to awaken the grumpy giant and when the giant gave chase he fell into the pit, where he was struck in the head with a pickaxe.

Although stories of giants are somewhat fanciful, perhaps this legend has its roots in fact. One of the ghosts spotted here is that of a tall man. Whilst no giant, perhaps the sightings of this tall-statured ghost is what has given rise story. After all, there are no firm records or accounts from when this tall apparition was first seen. What is even stranger is that following excavation of an exposed doorway in the nineteenth century an apparent hermit's cell was discovered with the mortal remains of a man reaching a grand 7 feet 8 inches in height.

The mount is also home to a spectral monk, although no further information as to what order or what time frame from whence this wraith originates from has ever

The giant Cormoran gets slain by Jack the Giant Killer in this Victorian woodcut image from a chapbook around 1820.

come forth. The apparition of a woman has also been reported. This woman, known as the Grey Lady, is believed to have been a nanny to the St Aubyn family who committed suicide by throwing herself from the castle's walls after becoming pregnant and then being rejected by the child's father.

If the haunting of the mount isn't enough for you then also pay attention to the surrounding waters, for seafarers sailing here have claimed to hear church bells ringing and the faint whispers of a voice stating 'I will ... I will'. This ghost is thought to be that of Sarah Polgrain, a woman who killed her husband and took up with her lover. The villagers didn't like how quickly Sarah took up with her new man and so she was convicted and hanged for the murder. Watching her execution was her lover, Jack. It is claimed that before she swung from the hangman's noose, she made her lover promise to wed her, a promise he made by saying 'I will ... I will'. Following Polgrain's death the lover confessed his promise to his crew mates before plunging into the cold waters to his death. It seems the bond between the lovers was a strong one, for Jack still utters his promise whilst the phantom church bells ring out for the wedding that never was.

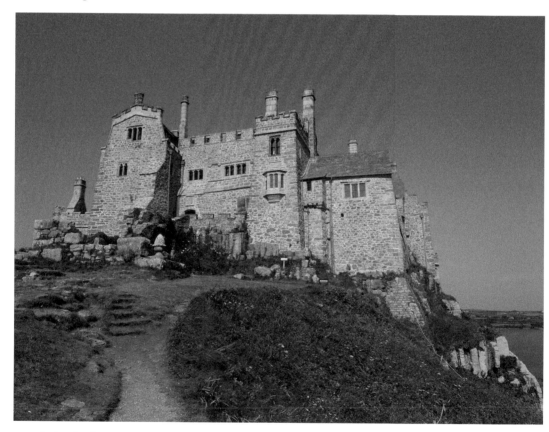

St Michael's Mount Castle is an imposing and haunted place to visit. (© Adrian Farwell/ St Michael's Mount, Cornwall, UK/CC BY-SA 3.0)

St Nectan's Glen, Trethevy

St Nectan's Glen has something special about it; an air of supernatural peace that is somewhat hard to explain. This patch of woodland, which beholds a lovely 60-foot waterfall, is a designated Site of Special Scientific Interest and is a place rooted firmly not only in myths and legends of fairies, pixies and ghosts but also home to a very interesting Christian legend.

It is said that King Brychan of Brycheiniog in South Wales had twenty-four children and of these twenty-four children the oldest was St Nectan. Nectan eventually moved into Devon and settled into the Stoke area, but it's claimed he also travelled and spent most of his life living as a hermit in various places, the glen being one such place in which he undertook his solitude. History would lead us to believe that the saint established his humble cell atop the waterfall.

A common story retells of the day that St Nectan helped a swineherd recover some lost pigs and as a thank you for his kindness the swineherd gave to St Nectan a gift of two cows. Two robbers found out about the cows and decided to steal them. Nectan eventually tracked the robbers down and instead of bringing them to justice he decided to attempt to convert the robbers to the Christian faith. They didn't convert. They murdered St Nectan and cut his head from his body in a heinous act against the peace-loving Christian man.

Tradition states that one of the robbers, following his murderous antics, died suddenly. The other robber went blind but eventually returned to the site of the murder to bury the body of his victim. It is said that wherever the blood of St Nectan fell, foxgloves grew. As a little closing twist to this story it is worth also telling you that there is a story that when he was murdered St Nectan picked up his own head, walked some distance then collapsed and died. Could this tale be the original 'ghost with its head under its arm' legend? Whatever the truth behind this fable there is one thing that can't be denied and that is the peace and tranquillity that permeates the glen to this day. Many people still visit the glen to offer their prayers and hang brightly coloured ribbons in remembrance of their loved ones who now no longer walk this mortal plane. The ghost of St Nectan has been spotted at the glen, as have the spirits of two women who are believed to be Nectan's sisters.

When I visited the glen, whilst writing *Paranormal Cornwall*, I spoke to one of the staff members present and asked her if the spirit of St Nectan had been seen in recent years. She replied 'Oh yes. He's been seen and his presence is felt at the glen every day. He appears dressed in a black habit, quite young in appearance. He always smiles and nods his head towards those who witness him.' What about his head I asked? Does he still carry it with him? She laughed and replied, 'No, his head is exactly where it should be.'

Above left: The waterfall of St Nectan's Glen, and indeed the whole glen, exudes an unexplainable spiritual calmness that has attracted pilgrims from many walks of life and faiths and continues to do so to this day. (© David Scanlan)

Above right: Many people tie ribbons, leave prayers written on stones and stack intricate stone towers in memory of loved ones lost. (© David Scanlan)

In addition to the above-mentioned spirits of St Nectan and his sisters there is also another interesting facet connected to the glen. Legend states that following the battle of Slaughterbridge, King Arthur and his followers stopped at the glen to rest and tend to their wounds. Their blood flowing freely from their injuries fell upon the stones in the water here and permanently stained them. They have since become known as 'blood stones'.

One of the Blood Stones at St Nectan's Glen. (© David Scanlan)

CHAPTER FORTY-NINE

St Nonna's Church, Altarnun

See Penhallow Manor, Altarnun.

St Senara's Church, Zennor

When I went to the old ancient church of St Senara's at Zennor I was quickly amazed at how many twisting, turning and narrow roads I would have to negotiate in order to visit it. Eventually I stumbled across a sign pointing me in the correct direction and although I expected the area to be small I was stunned by what I saw upon arrival, for the area only had the church, a smattering of houses and a very small public house. The only noise you could hear was the crash of the sea upon the rocks in the nearby bay. Upon entry I gathered up a small leaflet containing the history of the church, which simply states:

> The circular graveyard is an Iron Age site overlying the Stone and Bronze Age boundaries of this ancient land. There has probably been a small Celtic church on this site since the 6th century AD. Our patron saint, Senara, is linked to the legendary Breton princess Asenora, who may have travelled from Ireland to Brittany in the wave of Celtic Christianity which spread into Cornwall during that time. The earliest record of this building dates from 1150. The tower was built and an aisle was added on to the north side in 1450. The whole church was restored in 1890.

Why come all this way and make all this effort to see just one church I hear you ask. Well, St Senara's has a very interesting artefact contained within its historical walls: the Mermaid Church! For me this is a bizarre emblem to find. A carved mermaid, a symbol of pagan beliefs stretching back to the times of the ancient Assyrians, is to be found in a Christian establishment. How did it get here and why is it here?

It is said that many years ago a local chorister by the name of Matthew Trewhella (sometimes written as Mathey Trewhella) used to sing in the church here. His voice was said to have been so beautiful that eventually his dulcet tones attracted the attention of a mermaid who would hide her aquatic nature by the virtue of a long gown. The locals noticed this mysterious woman would visit their church, listen to the choir, and then depart before the service came to an end and everyone else left. No one could ever find any trace of the strange woman upon leaving the church. As time passed legend tell us that Matthew became infatuated with the woman and she confessed to him her true nature, being that of a mermaid. Not put off by this, Matthew is said to have picked her up and carried her in his arms to nearby Pendour Cove.

Matthew was never seen again and despite searches he was never found. No one knew what became of the chorister whose singing had attracted the love of a mermaid.

Some months later – some sources say around five months – a fisherman dropped anchor In Pendour Cove and was stunned to come face to face with a mermaid's head rising up from the watery depths. The mermaid politely asked if the fisherman would move his anchor as it was blocking the doorway to her home and she wanted

to return home to Matthew and her children. The fisherman is said to have promptly raised anchor and set off to seek out the Trewhella family and tell them the news of his fascinating encounter. That is how, to this day, the story of Matthew Trewhella and a mermaid's love for him continue. The mermaid's chair was carved approximately 500 years ago and is testament to the legend.

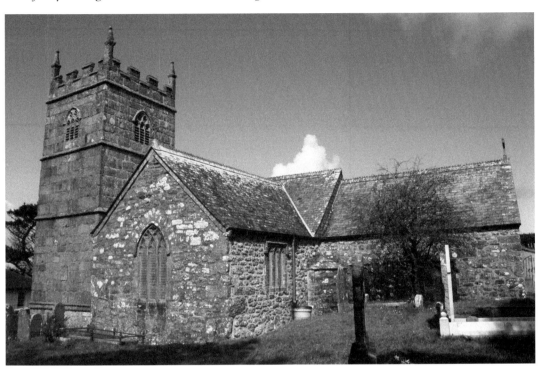

Above: The Parish Church of St Senara at Zennor. (© David Scanlan)

Right: The 500-year-old Mermaid Chair. (© David Scanlan)

CHAPTER FIFTY-ONE

Tintagel Castle, Tintagel

Tintagel Castle simply has to be one of the United Kingdom's most mysterious castles. It is said that the famed English monarch King Arthur was born here, but despite its mysticism and romantic lure the castle today is nothing more than ruins.

The magic of Merlin the Magician has long since vanished from this historic icon; however, if you're lucky then the castle itself may be able to enthral you once more with its spectral return to grandeur, for it is said that on occasion people have witnessed the ruins simply fade away to be replaced with the image of the castle in all its former glory.

Some years back a Dutch husband and wife were holidaying in the area and were walking on the cliffs of Tintagel when they had a very unusual encounter. Out of nowhere they witnessed a man on horseback wearing a wide-brimmed hat, black coat with white pleats and embroidery and soft leather boots with spurs. The horse came to a halt and the man dismounted and tied his steed to a nearby branch. The Dutch gentleman said that whilst they were watching this figure the air, all of a sudden, seemed to shimmer and the man and his horse vanished from sight. Did they witness the spirit of King Arthur, a member of his court, a smuggler ... or could this experience have some other, more mundane, explanation?

Beneath Tintagel Castle lies a 330-foot-long cave known as Merlin's Cave. Rumour has it that the cave is haunted by the ghost of the mystical magician Merlin. Should you choose to explore this cave then be warned, for the cave fills with water at high tide and becomes very treacherous.

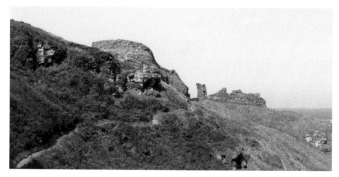

Above: Only broken-down walls and crumbling rock still stand as the testament of what was Tintagel Castle, a critical and magical ruin in the history and folklore of Cornwall. (© Robert Linsdell/Tintagel Castle, Cornwall/CC BY-SA 3.0)

Right: Merlin's Cave nestled below Tintagel Castle, where the spirit of the long-dead magician is said to inhabit. (© Oxiego/Merlin's Cave/CC BY-SA 4.0)

Wellington Hotel, Boscastle

Many famous guests have spent a night at the Wellington Hotel in Boscastle including the Duchess of Sutherland, King Edward VII, Thomas Hardy, the Duke and Duchess of Westminster and Sir Francis Wyatt Truscott, who was a former Lord Mayor of London. Despite the many prestigious guest visitors, there was one in particular whose name jumped straight out of the guestbook at me: that of the Revd Sabine Baring-Gould (1834–1924). For those of you who don't know who he is or why he was famous then allow me to explain. Baring-Gould is best remembered in the Christian community, primarily, for the writing of classic Christian hymns such as 'Onward Christian Soldiers' and 'Now the Day is Over'. But for me, and indeed many others in the field of paranormal research and investigation, he is best known for writing such classics as *The Book of Were-Wolves* (1865) and *A Book of Ghosts* (1904). The latter of these can be found free of charge online.

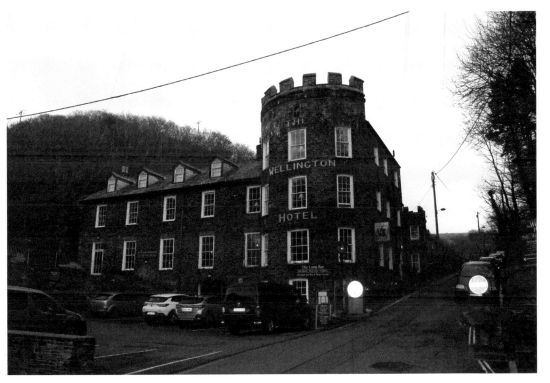

With three ghosts haunting this lovely hotel you'll be spoilt for choice. If you're wanting to experience the paranormal then rooms 9 and 10 come highly recommended. (© David Scanlan)

Part of me wonders if Baring-Gould knew much about the ghosts that haunt the Wellington? One of the ghosts reported here is a man dressed in a frilly shirt, coat, leather gaiters and boots. On one occasion he was actually witnessed by a former owner of the hotel and initially the owner didn't suspect that anything was untoward with his guest until that guest abruptly disappeared in true, traditional ghostly fashion by walking into a wall. If you do happen to book a room here and fancy a bit of a spooky experience then Rooms 9 and 10 come highly recommended. If you choose one of these rooms, especially with the desire of encountering the paranormal, then please don't be too disturbed should you awake in the night to find the resident ghost: a little old lady who has been seen sitting on the end of the beds and has even been seen walking through closed doors.

The final ghost at the Wellington is a little more mysterious. Although we don't know the identity of the two previously mentioned ghosts, we can at least identify them as former humans. The third ghost is a little harder. When it appears it is usually seen as an indistinct cloaked figure that walks out from a solid wall and then makes its way through a window. The story connected to this particular apparition is a common one in paranormal circles. It's a story of a young lady who was unlucky in love and is said to have jumped to her death from one the hotel's windows. Sadly though this must remain as pure speculation as witnesses to this ghost are not able to tell what gender the apparition is let alone the ghost's full story.

Wheal Coates, St Agnes

Sitting on the clifftops between St Agnes and Porthtowan lies the tin mine of Wheal Coates. The shafts of this now long-disused mine are haunted by the ghosts of miners who once worked in the dark and dangerous conditions that go hand in hand with mining.

Although the current remains of the mine date from 1870, the actual mines were in use for many centuries. The site is a UNESCO World Heritage Site and ranks as one of most photographed mine buildings anywhere in the world.

If you happen to visit the mines, while taking in the stunning clifftop views be sure to keep an open ear or two for you may be privy to hearing the sounds of the long-dead miners still chipping away for their precious tin ore.

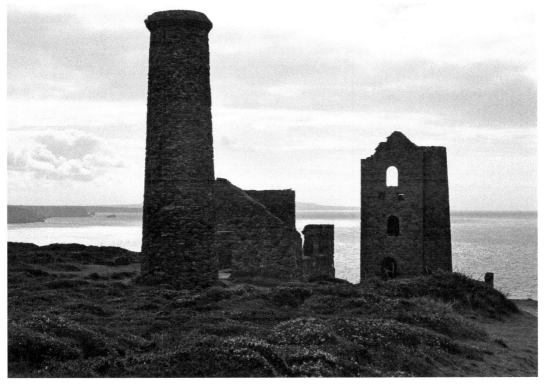

The engine house at Wheal Coates. Could the spirits of long-dead miners still be clocking in for work every day? (© Nilfanion/Wheal Coates Whin and Chimney/CC BY-SA 3.0)

William IV Public House, Truro

Just half a mile north of Truro city centre is the small parish of Kenwyn. Here in Kenwyn Street lies the William IV public house. In 1259 Bishop Bronescombe led the dedication service for the Dominican friary that once stood on this site. The friary was expanded in the fourteenth and fifteenth centuries and eventually encompassed a church, cemetery, chapter house and even its own well. Upon the dissolution of the friary under Henry VIII in 1538 it was noted that the friary had a prior and ten friars. With this level of monastic inhabitants on the site it should come as no surprise that the pub has a ghost, it's very own phantom friar.

Bibliography

Alexander, M., *Phantom Britain* (1975)

Bagot, M., Beast of Dartmoor Mystery SOLVED (2016)

Baring-Gould, S., *A Book of Ghosts* (1904)

Becquart, C., *Cornwall's Most Believable Ghost Sightings and Paranormal Events* (2018)

Blackmore, S., *The Journal of Nervous and Mental Disease – Out-of-Body Experiences in Schizophrenia – A Questionnaire Survey* (1986)

Deane, T. and T. Shaw, *Folklore of Cornwall* (2009)

Ewart, G. and B. Ho-Tong, *Executions at Olde Bodmin Gaol* (2010)

Grego, Peter, *Cornwall's Strangest Tales* (2013)

Hallam, Jack, *Haunted Inns of England* (1972)

Hunt, Robert, *Popular Romances of the west of England* (1903)

Johnson, Bill, *Guide to Bodmin Jail and Its History* (2011)

Jones, Richard, *Haunted Inns of Britain & Ireland* (2004)

Journal, Royal Institution of Cornwall, Volume X (1890–91)

Mullins, Rose, *The Inn on the Moor* (1998)

Sutherland, J., *Ghosts of Great Britain* (2001)

Tyrell, G. N. M., *Apparitions* (1953)

Underwood, Peter, *Ghosts of Cornwall* (1998)

Underwood, Peter, *A-Z of British Ghosts* (1992)

Underwood, Peter, *Haunted Gardens* (2009)

White, Paul, *Classic West Country Ghost Stories* (1996)

White, Paul, *Classic Cornish Ghost Stories* (2010)

About the Author

David Scanlan has a long-standing interest in the paranormal. He was born in Portsmouth, Hampshire, in 1975 and was raised in a household where everyone was open-minded in regards to the possibility of life after death. His earliest recollections of ghosts came in primary school after hearing tales surrounding the appearance of a 'White Lady' in a nearby graveyard who was murdered in the eighteenth century. Her tombstone still carries the whole bloody saga of her demise.

In 2001 David established the Hampshire Ghost Club whose aims were, and still are to this day, to investigate claims of paranormal phenomena and where possible record this evidence for dissemination amongst the public at large. The Hampshire Ghost Club gained a high reputation quickly and still stands out as a major 'ghost hunting' society investigating all sorts of locations around the UK but specialising in hauntings of the county of Hampshire. From 2002 to 2006 the Hampshire Ghost Club were resident at Hampshire's most haunted house, Wymering Manor, and were responsible for a majority of the research and investigations that went into bringing the house to prominence amongst the paranormal community, a factor that would ultimately help save the house from potential demolition.

The public have seen David's work in action in the international, national and local media including appearances on TV's popular series *Most Haunted* and *Most Haunted Live*. He is the author of *Paranormal Hampshire*, *Paranormal Wiltshire*, *Paranormal Sussex* and co-author of *Paranormal Essex*.